Country Miles are Longer than City Miles

Merry Christmas
1981

To Trudy —
Who, more than anyone
we know, will appreciate this
compilation.

With Love,
Mommie & Daddy

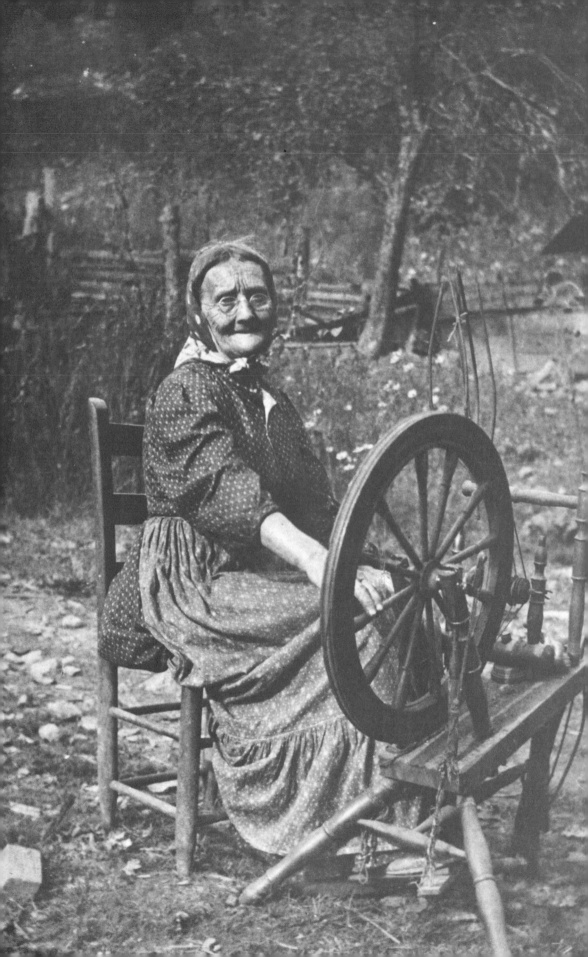

Country Miles are Longer than City Miles

by Craig Evan Royce

Photographs by Jeffrey Gitlin

Ward Ritchie Press
Pasadena, California

Library of Congress Catalog Card Number: 75-18098

ISBN: 0378-07897-6

Printed in the United States of America

For Marsha Sue
and MacKensie Victoria

Table of Contents

Acknowledgments

There are always so many others, but without the vision of the following this project would still be merely an idea: Berea College; Mr. and Mrs. Earl Keith Royce; Chester Cramer of the Red Bird Mission; Dr. and Mrs. B. W. Craft; the Morrill County Community Craftsmen; Barbara McCord; Brunner Studios; Susi Hartmann; Dr. Jean Pival; Grace Perriah; The Kentucky Guild of Artists and Craftsmen; Barry M. Bleach; Thomas Hill of The Upstairs Gallery; Adrian Swain; Buck and Betty Jo Coldiron; Council of Southern Highlands Bookstore, Berea; Peter Richard Wolf; David and Billie Shulhafer; Liz Hollinde of E.F.S.I.; Jacques Garnier; Barbara Cox; Shauna Bernacchi; Ronald Swan; Middle Kentucky River Crafts; Pauline Coldiron; Helen Burg; Captain and Mrs. S. I. Hansen; Marge Gregg and The Jubilee Center; William Chleboun; Dr. Robert Bester; Ester Bentley; Arthur and Janet Howard; d. mitchell le Blanc; Annville Institute; Aunt Marie Weldon; Mary Condon, Jackie Coldiron, Louise Watkins Kimmel; Sherri Butterfield; and Sarah Lifton.

Country Miles are Longer than City Miles

Historically, Kentucky helped breathe the breath of life into America. The first white explorers to see the western horizon passed through a wide gap later named the Cumberland Gap, camped, settled, and grew in Kentucky's vast, lush meadows. It had taken millions of years for western man to confront those Appalachian Mountains, to traverse them; and if these Kentucky meadows had not provided a life-giving force, the history of western man, indeed, western civilization, might well have been quite different.

In 1770 Dr. Thomas Walker and five companions walked through the "Cave Gap," a passage through the Cumberland Mountains used by Indians long before any other race set foot upon Kentucky. These were the first white men west. They were explorers for a Virginia land company, so it must also be noted that theirs was also the first "business trip" west, a not-so-subtle commentary on "Manifest Destiny."

In 1773 Daniel Boone noted:

> *These mountains are in the wilderness, as we pass from the old settlements in Virginia to Kentucky, are ranged in a Southwest and Northeast direction, are of*

a great length and breadth, and not far distant from each other. Over these nature hath formed passes, that are less difficult than might be expected from a view of such huge piles. The aspect of these cliffs is so wild and horrid, that it is impossible to behold them without terror.

With this coming of Daniel Boone and five other families from Virginia, the west was officially opened, western thought and deed began, Disneyland was made possible. This thrust halted momentarily to bask in the vast richness of the meadows. Settlements sprang up; the lowlands were conquered.

There existed, of course, among there first settlers, those who shunned the rich lowlands and ascended the "cliffs so wild and horrid." On foot they traveled, carrying with them only those articles they felt were essential for their existence. Life for these first families was simply enduring and learning that which nature chose to teach, never the same lesson twice, always a slight difference in the path the hickory leaves took as they fell to earth—lessons only the strong hand and discerning eye could learn.

Even today, there exist small pockets of human beings who live close to the purity of those first pioneers, who have learned the importance of watching the sun rise and of listening to the voices of the wind, daily, hourly, and perpetually. Down through the centuries, they have stood ready to teach lessons that have been disregarded and scorned by western civilization, and cast aside in favor of western tinsel. Now, it is important to our very existence that we learn from the beauty, purity, and simplicity of these people.

Late in the summer of 1967, I began to document, though ever so slightly, this driving force. Who are these persons? Who is this woman Louise Calvin who waits fifteen years for a tree limb to tell her what it is to become, who has never desecrated a living thing to sculpt, who sees faces and life where you and I are afraid to look? Who is this man Oaksie Caudill who must wait for the sap to rise so that he can color his white oak baskets blue and brown, who lives above Kingdom Come, who can split a six-foot piece of white oak with a Case knife to a sixteenth of an inch with one steady thrust? Who is this woman Martha Nelson who has seen and created all corporeal existence in one nylon sculptured face, who has wept as her "children" leave her, who excuses a sculpture that is "playing Woody Guthrie today" to the faint wail of "Rangers Command"? Who is this man Jess Patterson who has daily traversed the Little Shepherd Trail to share a love of wood with children on the Pine Mountain, who strums his dulcimer so tenderly that he must put his ear within inches of the instrument to entice that plaintive voice he placed in it?

They are but a quick glimpse of that vital force whose energy must be shown, must be shared. Theirs is the story of mankind's at-oneness with himself and his environment, his country and his art.

How can this force be contained within the covers of a book? Does a book possess too many boundaries to explore fully the boundless? Is this force really a lyric? John Jacob Niles has devoted his life to this lyric. He, as no other human being, has fronted this essential natural rhythm. Doris Ulmann did not hear it as deeply as she saw it in hands and faces. Jesse Stuart was conceived from this force and has captured it on paper. I am moved by specific

corporeal manifestations of this force or natural rhythm, so this study must, in part, be highly visual.

America and the American people are experiencing metamorphoses. The bowels of the earth upon which the traditional handicrafter stands are being ripped out, leaving scars on the land and on the soul that shall never heal. In a short span of time—three, four, five years from today—there will be few white oak trees left for Oaksie. Those groves will be plowed under to make way for coal trucks. White oak baskets will be replaced with brown paper shopping bags. Whether this is human progress can only be determined in time.

Myriad books and documents, studies, research papers, and art pieces have sought to preserve this traditional culture and will live on as long as intellectual society deems them essential. But, isn't it time for us to look a bit closer at what has life, lives, and breathes? Isn't it blatantly evident that studies, histories, documents, books, percentage points, and even prime time television programs cannot infuse the artificialities of our existence with the realities of life? Strip away the denim, plastic, and tinsel; the need is for human skin, hair, eyes, touch, feeling—the present. It has been observed by great minds since the beginnings of recorded history that we must put off crass materialism to survive in this human condition. This text is an attempt to force this issue.

This study covers many points on the mandala. It is for those members of artistic society who wish to study the technology behind the art and handicraft. It is for those members of artistic society who wish to bathe their eyes in beauty, a totally visual experience. It is for that segment of mankind which devotes itself to the search for an essential

force. It is for historians who wish to ponder that which has preceded now. For those looking to the future, it shall issue forth hope. It shall usher in a new artist and handicrafter, nurtured by the same physical and spiritual surroundings.

There exist but a scant few of these traditional artisans. Human progress has eroded their civilization, and most of their young are simply not willing to wait for the sap to rise; however, a young group of artists is creating, not the same objects, but new ones. The vital force of which we spoke before permeates these new creations, as if the souls of both traditional handicrafters and more current artists have been interfused. It is as if the same small voice that often trails off into song at the end of a statement exists in both Delta Hall's and Louise Calvin's dialogue. The true beauty of the statement is that both Delta Hall and Louise Calvin live. They are not fictional; they can still teach to those who look.

And look is all one need do for the following pages. They describe subtle gifts from people who may care for you more than you care for yourself. Their caring is deep and eternal, a part of the rhythm that is always there if one just stops to listen, gaze, and feel.

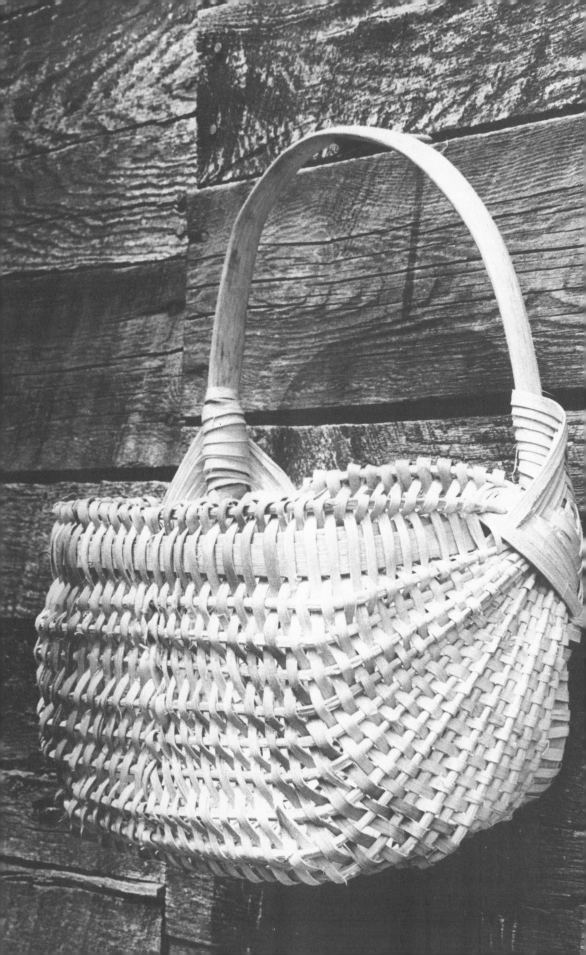

Just a Little Above Kingdom Come
Oaksie Caudill

He lives as high in the hills as you can see, unless you can see beyond Kingdom Come. In winter, he is the color of winter; in spring, that of spring; in summer, that of summer; and in autumn, the color of autumn. Sometimes you may think he is a tree, until he takes off his gloves to shake your hand. He starts about twenty feet away and slowly exposes his brown hands. He clasps yours, and you are welcome, welcome above Kingdom Come. He will always remember you. He is quiet and still even as he moves, exhibiting a complete control over his flow that only years of sureness and confidence could have developed. His every movement is that of a slow-motion thoroughbred, graceful, powerful, controlled. While traversing the glades, stoney tobacco patches, his porch, or playing "Ole Joe Clark," he is the rhythm of now, the rhythm of the ages.

Oaksie Caudill sculpts split white oak baskets. He has never had a teacher. His creations are the interfusions of his vision, his touch, and utility. He will tell you of times past and of the ladies of the mountains who used to make white oak baskets, but he doubts that today's child can learn his art.

Now the mountain shrinks under the burden of overloaded coal trucks and the sudden influx of Ohio and Indiana licenses. With every spring rain, a bit more of Oaksie's earth begins its slow journey to New Orleans, never to return. Still and quiet, Oaksie watches it slip away; still and quiet, Oaksie moves among the mountains collecting his white oak, what precious little remains.

He is true to the mountains. He loves the mountains that have nurtured him. Harbingers of revived coal industry rush past his land and over his mountain. He is deeply aware of their rapid pace, yet his presence seems to slow the rush in a little way.

You must, ofttimes, look for Oaksie Caudill. First you glide through the lush gentle valley on rocky roads flowing beside myriad streams and brooks. You are mesmerized by the gentle flow of the environment—past a farmer, friends, and a mule. You stop for a cow crossing your path, then continue past two general stores, white gas pumps, and pockmarked children. Kingdom Come passes to your left as a coal truck quickens your pace, awakening you to the realities of your home, then bringing unease.

The valley quickly changes grade, and the climb begins, past vernal farms and Pontiac skeletons. Thin-waisted pines dot the roadside, and also an occasional rhododendron waxes green. At these heights, grey concrete "Get right with God" signs seem monumental. You glide around a bend on a one-lane road through the pine and butternut, oblivious of all save the environment and a seven-foot cross proclaiming your Savior's graces. The road to Oaksie's hill is unfolding.

Winter has been hard on the road to Oaksie's hill. Winter has been long and trying for the ones on Oaksie's mountain. They are ready once again for growth, milling,

and moving upon the mountain as if it were possible to force spring from the tan earth, to wake new growth from its slumber. Yet it remains chill and grey while the mountaineer waits. Oaksie pauses and taps his pipe, staring into that chill and grey.

Oaksie Caudill is a man of the mountains who lives with a cat. Dogs are always close and friendly, but Oaksie lives with a cat. It moves under the baseboard of the cabin, hoping, even though there are guests, to take its customary place near the small coal fire. Oaksie sends it scurrying to the kitchen and beyond.

The cabin is low and dark, clean and neat. It does not possess the feeling of the ages, just of age: it is a cabin of the present inhabited by a man of the ages. A man living by himself for a long period of time creates the order usually missed by family living. Seventy-five-year-old photographs of the ones important to Oaksie and farm store calendars from selected years adorn the walls. He is a man who lives outdoors, so the rooms remain muted, neither dark nor light.

Oaksie's speech is deliberate, heavy with rich mountain accents. He reads much and is an immensely articulate man. He speaks low, forcing attention. He speaks from years of mountain life, so you are eager to be still and listen.

Oaksie looks up from his fiddle just long enough to smile at you, then returns to its company. In the warm, muted cabin, Oaksie fiddles for himself, his instrument, and you. He has heard of others, drawing their bows throughout the great southern expanse, yet no comparisons are allowed. He tells you, "We all do it differently, have to do it differently." He plays of a time when people danced to songs we consider legends.

Oaksie Caudill

9

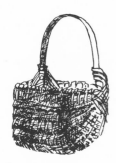

The road flows by Oaksie's cabin so, of course, the world flows past Oaksie's cabin. You are inside, however, and for great periods, time itself stops for you. Oaksie, and his cat. The fiddle is cast aside, and he disappears into his bedroom, returning with white oak baskets.

Like the man and his mountain, Oaksie's baskets are designed to stand against the ages. Never before have you seen such carefully sculpted, naturally dyed, useful baskets. They reflect the man and his land: the subtle shades of a weatherbeaten face, the tired earth. Oaksie has learned to make color appear where no color was before. He coaxes the "essential" beauty and color of life from the soul of nature.

Oaksie must go a mile from his home to find a proper stand of white oak. To you, the mile doesn't even register as distance; but to a man who has spent over sixty years within a mile of his birthplace, a mile is the journey of life. It is a day's work, a long day's work to collect enough white oak to make two baskets.

Oaksie will readily tell you the great stands of good white oak are near extinction. No one is to blame: they are victims of the crush of American civilization.

After Oaksie carefully selects the white oaks logs he will use, he transports them to his cabin. They are usually four to six inches in diameter and five to six feet in length. With the steadiness, strength, and assurance born of a lifetime, he splits each log lengthwise into strips one-sixteenth of an inch thick. Using froe, large Case knife, mallet, and his hands, he turns the oak logs into sculptures.

The time to collect the oak is when the sap is up and on the first day of the new moon, the time that life is stirring deep within the wood. Oaksie has learned the

secrets of extracting that life and making it blossom on the oak split. Soaking the oak when the sap is up and on the first of a new moon brings the color from the heart of the wood to its surface. As if developing a photograph, he observes the process, then removes the split from the water after the blue or brown has worked its way to the surface. Oaksie weaves these splits through ribs and handle of white oak, and a basket is created. He tells of recently repairing baskets that have endured seventy years of mountain life.

Oaksie's baskets are the cycle of life. He has planted the seed upon his mountain and asked for it back, always remembering to nurture it and keep it alive. He has called forth a beauty nature itself did not know it possessed and then returned it to the earth by way of you as a messenger, asking only that you keep it alive, that you keep the circle unbroken.

Oaksie has lived just a bit above Kingdom Come all his life with little formal schooling. He has lived in harmony, appreciating the contours of his life, never fighting the flow, learning rather to use it. He still has visions of the days of the great John Fox (author of the last literature of "classic" proportion written about the southern highlands) and daily watches the mists ascend his mountain. He does not see the top of the adjoining mountain laid to waste and has shown you a small scar ten miles away through the rain. Usually, he looks down to his hands and the earth. He has learned that, looking out, one sees too many scars and a world moving too fast to discern.

Now it is time for you to descend the mountain. Today you learned the beginnings of the true story, just one small essential. As the grey mists move past you to be lost above the naked trees trying so gallantly to bloom for their mountaineers, you are conscious of Oaksie drawing his

Oaksie Caudill

11

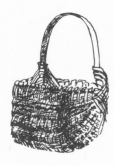

bow on one small string of your life, playing a soulful yet greatly affirmative cord.

Why is it so important that we listen, gaze, and feel in these specific fields and forests today?

Moving slowly below the palisades with the river, in silence we look. This river that rarely sighs moves as it has for centuries, rich with the colors of earth, green and brown. It derives its energy from the earth, for high among those cliffs lies its source.

People who dwell in meadows and passes are witnessing the senseless destruction of their earth. Heavy trucks traverse roads that are no more than wide paths between the glades and hills. Filled to overflowing with coal, they too flow with the silent brown river. Yet their flow has not been nurtured by tranquil looking and listening: they are born of another culture, whose essential force is capital gain, no matter how small. They come off the interstates and freeways and move swiftly up through mountain passes, causing the earth to tremble below their burden. They head east and north and south and west, leaving behind the earth lying open and exposed, cold and alone with no warm quilt to cover it.

These men and women who, as their parents and grandparents did before them, wait for the sap to rise to draw only the natural and pure color from the earth, these souls who weave lacelike honeysuckle to carry fruits from the earth, who work until hands bleed, for months at a time, to create a quilt for the child who sleeps below the rainbow of its fabric, warm and secure, these men and women who listen so still to the lyric that surrounds them, these people wonder at this destruction. When the wind is still and they listen closely, they hear the low growl of diesel

engines. They see their earth run unchecked to the clear waters, and earth and water become one in color and direction. To escape, they move higher among the cliffs. Leaving the meadows behind, they have moved slowly up the laurel slopes as those who do not understand their existence have come closer. Now they see the mountain peaks and know they cannot go beyond; they must make their last stand. They must quicken their pace, something they are not used to doing and have no need or desire to do. They have been forced out of their own pace to run another's race. Yet the history of man clearly shows that he who strolls among the rhododendrons and watches and feels shall endure.

Oaksie Caudill

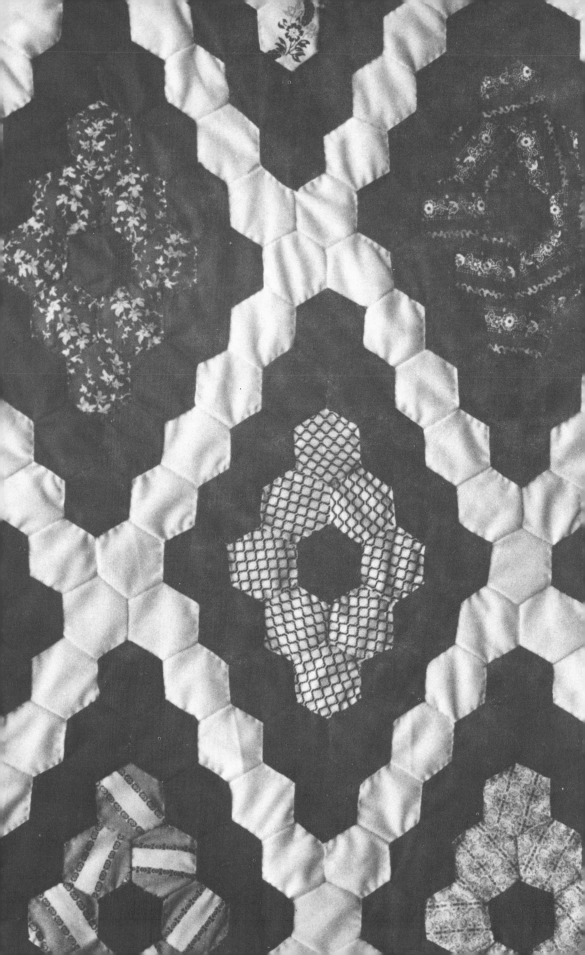

Perplexed at Five Miles per Hour
Delta and Belva Hall

From Cumberland, one either flees with the river or crosses the great mountains: there is no other choice. To the west across the mountain and the Little Shepherd Trail lies the valley, the valley where the past is the true present and the present rushes past. Just a little west of the great valley where Jacob's Creek empties, the same valley that William and Sal Creech educated, you turn to a dirt and gravel road like so many that follow the small creeks and brooks of the Kentucky mountains. Your vehicle climbs at about ten miles per hour, maybe five, and you must look very close to the earth to follow the faint trail of those who have passed before you. The great eight-cylinder engine of your vehicle leaps ahead, wrenching its control from you for four-foot intervals as you climb. You have never been out of control at five miles an hour, and you are perplexed. The valley falls off to your left. At the top of the road, you pause to view the valley in its majesty, then vanish into the rhododendrons. The road leads past massive lichen-covered boulders just to the side and partway up the hill. All is still save that voice of the ages you discerned long ago when you were young and stood alone among the hills, listening to the subtle

conversations of wind, leaves, and limbs. You realize you have always longed to converse with them and have, perhaps, missed their company, for today they tell you welcome once again.

At its zenith the sun is distant, and snow lies along and on the road, melting into pools where the sun hits. Your car moves on down the road, at times sliding into pockets that may hold you for some time. It means little. You are in a virgin forest.

Before you, two grouse strut into flight. The beauty around you is too much to ignore, and you understand why country miles *are* longer than city miles. The road does not diminish nor does it enlarge: it is constant in its journey into the heart of the virgin land. Passing the sites of old coal mining operations, you are amazed at how unspoiled the immediate environs are when that mineral is sought in the bowels of the earth rather than sliced from its surface.

Finally your vehicle once again ascends, and on the top of a knoll you spy a barn. It is a barn of timbers, all hand-riven many years ago. On either side of the barn lie cornfields, small and neat. A dairy cow wanders through the smallest, then crosses your path.

The door of the farmhouse is opened, and you are greeted by Delta Hall, a grand lady of the mountains. Seated around her dining table are four other people. "Supper" is being served, and you are immediately invited to feast. As you look into the eyes that surround you, you become aware of the wonderful feeling of ease that permeates the kitchen.

Rich and beautiful mountain accents mingle with the gentle voice of a brook that meanders not fifty feet away. The conversation concerns quilts, for that was the reason you began this journey. You had heard that Delta and

Belva Hall quilt. Moving into another room Delta Hall begins to unfold quilts, and you are amazed by the extraordinary color patterns and schemes that blossom before you. This lady has lived her entire life in the same house, has watched the same trees blossom for over fifty years, and has now learned to record that vision, in a small way, on her quilts. Only a life unfettered and divorced from the pace you lead could create the overwhelming presence of freedom in these quilts. It is as though Delta and Belva Hall had lived their lives without ever having to blink.

Conversation now turns to the history of specific quilts, and when you are told that the quilt you hold was designed by Delta and Belva's father on his death bed, you are moved.

The Hall sisters have not been quilting for ages. They have, however, felt the warmth of their mother's quilts and that massive comfort that covers Jacob's Creek.

The countenances of those who fill the small room with the big stove are still mesmerizing as they look at and through you. When questions drift from their quilts to the human condition, however, they become perplexed.

Delta and Belva Hall become radiant when talk shifts to the valley's past and the force that seems to spring from it, giving life to those who are patient and sure enough to seek it. They talk of the mountains, not in terms of economics or of life and death, but of moments alone on Jacob's Creek or deep among the rhododendrons. They know that it is from these glades that life springs forth for the people of their valley. Sociologists, historians, health agencies, and writers all seem distant when Delta talks of the purity and energy the mountain gives. They have not felt that energy come alive in writing and studies since the turn of the century.

Talk drifts back to quilts and to the joy both ladies derive from watching their small patches grow and take on meaning before their eyes. A small, insignificant piece of gingham becomes the center of the complete blazing star.

In musing on their happiness, nothing is more apparent than their total trust in their church. Two wonderful women, who see things and have observed in a way we only dream of, will sit in their cabin, the Hall cabin, with Jacob's Creek speaking just outside the door, and tell you, with their eyes only, of their faith. There is absolutely nothing to question.

Most members of the Hall family have left the mountains and Jacob's Creek. Occasionally, they make a pilgrimage back to the land they love. You can spot them on the desert in a large Pontiac loaded to the roof moving slowly across plains, moving toward Jacob's Creek, often driving straight from California or Kansas.

Arriving in winter, many of the younger ones are taken aback to find the foliage diminished and the cabin surrounded by skeleton trees. For the Halls of America, the vision will always remain one of lush spring and temperate summer when the hills are full and warm and the valley is a jungle the naked eye cannot penetrate. But when they have journeyed the great land, crossing every possible terrain on earth, they know Jacob's Creek to be as it was in their youth, perpetual spring and summer, when everything seemed bigger and stiller than life. The objective view of a black-and-white winter often proves too much.

Delta and Belva Hall ask for little. They do not dream of the human condition; but every Sunday when fifteen to twenty of their friends follow them home from church to sup beside Jacob's Creek, the human condition seems distant. For around Delta Hall's table much goodness sits.

18

In the company of those from the surrounding hollows and ridges, even Jacob's Creek sings an octave lower.

The cabin once again seems too warm, so you follow the sound of Jacob's Creek out the door to the porch upon which you stand and gaze into a profusion of color set against the retired afternoon overcast.

It is time to leave Jacob's Creek. Potatoes must get in the ground before it rains, and country miles are longer than city miles. The eyes never leave you as the dogs guide you to the gate. Suddenly, there appears the form of a man carrying three or four six-foot timbers on his shoulder. He is moving slowly down the knoll toward you, past you, and to the small timber shed by your car. He smiles, you nod, and he expounds in rich mountain accent upon the day's labors with the simple wisdom of the ages. With his hand on your shoulder, he assures you, "You are always welcome to Jacob's Creek."

Your road follows the creek out, and you look for the man who isn't there. By an exposed seam of coal, you stop and cross an ancient bridge on foot. The entrance to the seam has been shut with shale. Revived activity on this land seems doubtful, but Delta Hall's voice when talking of the forest rings true and clear. You are aware that the road will never be the same to you again, Delta Hall has taught you to look at it very closely every time you move on it, and her quilts have, in a small way, captured it for the ages.

Leaving the creek behind, you begin your descent past the laurel and the walnut. The eyes that have followed you throughout the day are now upon the earth seeking out the light green of spring and new growth. Delta Hall is born again with every spring. From the top of the last ridge, you look down into the valley, the eyes of the afternoon heavy upon you, and for one brief instant the entire vista turns green as the virgin spring overpowers the receding brown.

Delta &
Belva Hall

19

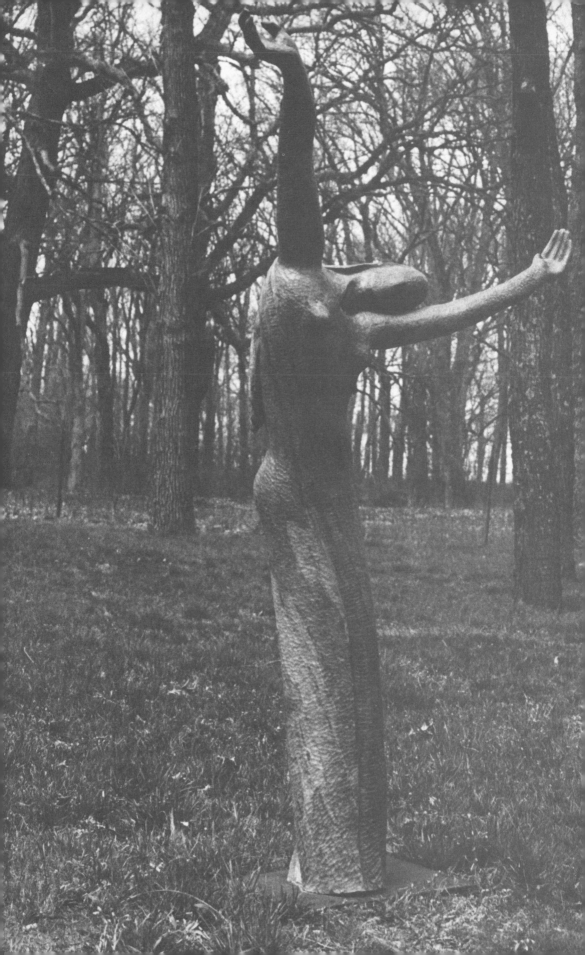

The Grace and Elegance of a Different Century
Louise Deese Calvin

Lexington holds many treasures. It is itself a treasure nestled in the grass they called blue. Though bent with age, Lexington's avenues maintain the grace and elegance of a different century. Looking down, you catch a glimpse of brick through the asphalt worn away by the passing of tobacco trucks and time. Here you can peer through dimly lit windows into the soul of America, for Lexington was once the capital of western thought and vision.

Magnificent trees abound in Lexington—poplar, elm, walnut, butternut, magnolia, cherry, pine—and nestled among the trees, in one of those stately and very still neighborhoods that have moved great men and nurtured great minds, lives Louise Deese Calvin. Though dignified, she is seldom still, for she is a teacher. Sometimes she teaches the student; sometimes she teaches mankind.

She was born stately in a small town in North Carolina, She was born intense with what she calls determination. Yet, lying on her four-poster in a second story bedroom with a magnificent vista of the sky, she would often watch the story the clouds would tell for hours on end. As a young girl, she read the great romances and the books with small voices, voices you may not have heard as you read

The Trail of the Lonesome Pine, voices she reminds you are there as you sit across from her in a still and quiet room among the tall elms and oak and walnut. Louise Deese Calvin lives in a forest within a forest.

As a young girl her favorite game was forming a giant human whip and spinning until one must let go. As you are drifting, a voice tells what guise you must assume, and one must assume it in flight. Her determination caused her to build and make things when she was young. Her hands became very important to her as she found herself preferring to build her own doll furniture rather than to buy it.

If one were to attach a permanent name to the Calvin home, it would be "House of Living Woods." Louise Deese Calvin is a sculptress. She takes dead and dying woods, limbs, branches and affords them eternal life, using but her hands, that small voice, and a face she saw from her bedroom window. It is her intention that no piece of wood she touches will ever die. It is not only her vision that causes the sculpture around you to dance but her technology as well. Each piece she has ever sculpted is coated with wax, wax that must be caressed several times a month for life. As the wax is rubbed, the once dead or dying wood comes alive again. Over a long period of time, hands change if they work the wax enough, and the wood changes as it is continually caressed; hands and wood grow and diminish together. Twenty years after the wood has been sculpted, you are giving it life and it is giving you life. How simple, pure, and important.

Louise Calvin's home is low and dark and soothing. Her porch houses assorted limbs and trunks of trees that neighbors have placed there, unannounced. All know that she sculpts and would not desecrate a living thing to do so.

Louise Calvin was educated in the public schools of North Carolina, Randolph-Macon Woman's College in Virginia, and Yale. At Randolph-Macon, she studied psychology. Traveling through the mental institutions of Lynchburg, she drifted away from the lyric of nature for a time and was caught up in the anguish of their inhabitants' drawn faces. Occasionally, even now, a face from those experiences returns to her as she sculpts. At Yale, she continued her study of the human mind with perhaps the finest assemblage for such, and married one of that group.

As a young girl Louise Calvin spent much time alone and feels that these solitary moments helped nurture her independence. When you are young and unfettered, when trees look bigger and days run on forever, the still voices of nature will talk to you if you listen. But her first real creative calling did not come in the form of a vision while alone among the dogwood. As Louise Calvin explains:

Louise Deese Calvin

> How I started carving came about in a very interesting way. In World War II while Jim was overseas he made me promise I would get a job. The superintendent of county schools came by the house one day and wanted to know if I was interested in teaching. I didn't have to get out of my chair to hunt a job like you must today, but after four hours of talking he hadn't mentioned a job, so I began to get suspicious. I said, "You know, something is awful funny. I bet you are going to ask me to teach math."
>
> He hung his head and said, "You know, you are right."
>
> "I don't want to teach math."
>
> He asked just for three weeks, and I said I could

23

do anything for three weeks. Three weeks carried into three years. That's where I learned math.

This was a little agrarian community, and for many of those kids, the biggest event of their lives was the junior-senior banquet the juniors put on for the seniors. The junior homeroom teacher was a good friend of mine, a fine teacher, but she didn't have a lot of imagination. The banquet wouldn't be anything if left to her.

The town had this community center about as big as a house. All one room. I went one day to see how they were decorating, and it was like any dinky plaything you ever saw. Driving home I decided that it would be awful nice to make this banquet something out of the ordinary. So I decided we would just have a circus. It was in the spring of the year, and circus came to mind. We would throw a big tent in this area, and with all these kids being farm children, this could be something special. I began to ask the students to bring in specific articles from the farm, tobacco canvas for the tent, for instance. And I asked for a tree for a center pole.

Well, the students went home, and the idea was jelled. At eight o'clock the next morning, there were those parents, about fifteen trucks with all that tobacco canvas, and that big tree, which the men planted. They borrowed all that was needed to throw up the tent that morning.

Going home that night, I wondered what good a circus was without a menagerie. And this is where the carving came in. I thought that, in any circus, you need a giraffe, a camel, some horses. It was well after store closing time. I called the manager of one of the local stores and got him to open up. I bought

24

all kinds of materials and for the first time in my life really created—life-size elephants out of cardboard and paper. I carted them over to the school, and they were an immediate success. From that time on I knew I could create.

Well, Jim came home from the Army, and I didn't do anything with this. Then in 1951, after we first built this house, I was getting ready for a party and it was the winter months and it is against my religion to buy cut flowers. So I went out to get evergreens and went downtown to try and buy some little birds for the evergreen. I could only find some horrible old plastic painted things that hurt my feelings, so I came home and went out to the wood pile and proceeded to carve twenty-four little birds—doves, and tiny cardinals that were lots of fun. The first figure I ever did is called "Infant Joy."

Louise Deese Calvin

Moving across a lawn under the umbrella of mammoth elms and oaks, Louise Calvin suddenly stoops down and picks up one-half of a black walnut shell. On the inside she insists is her face if one just looks close enough.

Sitting in front of her class at Transylvania University, she watches fifteen students hard at work looking for that same face. Suddenly, she asks them to halt as she starts up, moving toward a wood chip, one of hundreds in the studio, asking the students to look at the face in the chip. They look and will continue to look for the face among the husks and chips of every day.

Louise Calvin began sculpting with western woods, but during the past five years has used only native Kentucky wood. Glancing across her yard to a neighbor's, she sees an elm log and mentions it will become a sculpture some day. If nature discards a piece of wood by wind, ice, or snow,

she picks it up, shelters it, and lets it tell her what it wishes to become. She refuses to kill any living thing. Her voice reverberates with anger as you pick living grass in front of her. Spying a limb that the weight of ice has drawn to earth, she will stop to shelter it and return for it later. Once inside her home, it may sit for fifteen years before it and she agree upon its shape.

When asked to define art, Louise Calvin remarks: "To me art is not reproducing something, but trying to get to the essence of your feelings about whatever it is you are doing. I am really anthropomorphic; the wood talks to you."

If you do not see or focus from a distance, she will accompany you to the tree, the limb, and point out a form you have never discerned before. She does not sit back in dialogue paying lip service to her vision but will pull you from tranquility, if need be, to front you with true essence: she will create it before you.

Louise Calvin quotes to her students the words of Bulliver: "The marble image floats into light not at the toil of the chisel but at the worship of the sculptor. The voiceless workman finds the empty stone." She says her students grasp that feeling. A good piece is in the wood already, and her job is to help show it to the student.

This woman, who gives life with her hands, creates life with her hands, who forces you to question the word *finite,* is a woman of great intensity and determination who, once she begins to create, produces in abundance. She is, however, quick to remind you that, when she works, it is eighteen hours a day for weeks on end. When the voices cease, so does she. You must put forth the effort and work, always pushing yourself to fruition. Far too many harness their creative powers, uncertain of their understanding of the definition of art.

There are too many tricks and novelties in modern art and life for Louise Calvin's taste, a very refined taste, and who wants to spend one's life with tricks and novelties she questions? Have you ever seen a novelty wagon late at night in half light?

In her years of sculpting, Louise Calvin has sculpted roughly five hundred pieces, including much marble. During that time she has used only chisels as she sculpts, save once, that a small drill. She has developed the hands of a master.

Besides study at Berkeley and a vision that Ann Green of Lexington has given her, Louise Calvin is a self-taught sculptress whose vision pierces the tinsel of your everyday world. Louise Calvin describes "The Dance of Life":

This piece up here I call "The Dance of Life." This couple is getting pretty old, and they have never known what life is all about. They have just kind of waltzed through the whole thing—that sort of feel. Something impresses you, and you see a piece of wood that tells you this. And it comes out.

At Berkeley she was allowed to grow at her own pace because her teacher understood Louise Calvin's vision. When she was unable to understand the speech of her professor, Czechoslovakian Bohus Benes, and he could not understand her southern accent, they learned to talk with their fingers. It was at Berkeley that her hands were taught how to channel their energy and she was taught the importance of mastering her tools.

As a woman who has learned to live harmoniously with her environment, a woman who has taught mankind many lessons, from algebra to healing with the hands, Louise Calvin rates with the great teachers of history.

Louise Deese Calvin

27

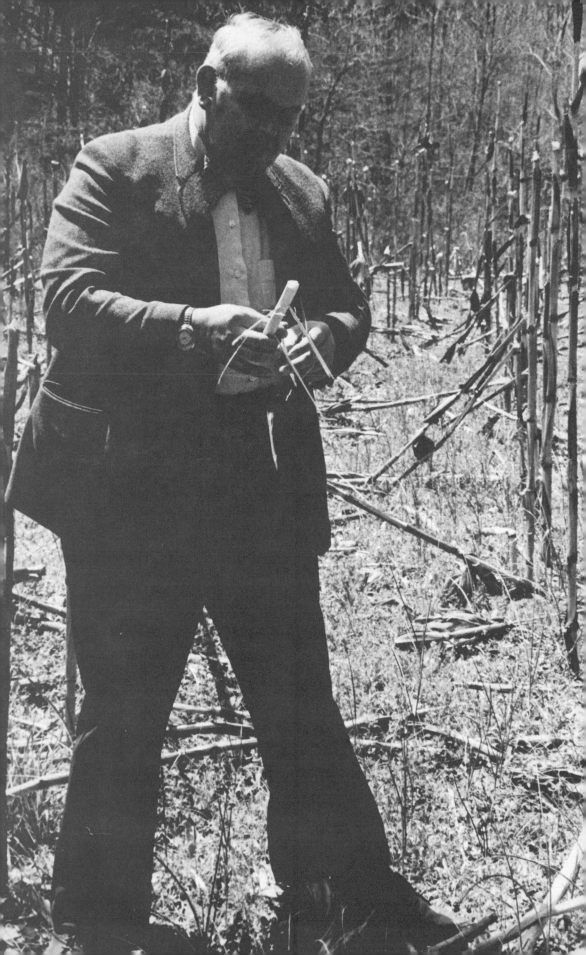

Visions of Madame Guyon
Reverend Alvin Boggs

He was conceived in the soul of his valley long before he was born. The valley of the Greasy and Laurel Forks. The valley of violets that even today have not been named.

He is a big man who moves with the deftness and force of nature if anyone or anything he loves is threatened with harm. The beauty of this man is that he loves far more than most. He will move along creeks and hollows to touch the hand of a dying friend or to explain the inequities of administrations and policies to an eighty-year-old person who cannot read or write. He will become a little child, gentle and pure of countenance, as he explains the toys of his children, then display the strength of several men as he argues for the future of the rural community in America.

The Reverend Alvin Bogg's voice has thundered throughout the mountain courtrooms of his country defending his people, yet he is moved by visions, visions of Madame Guyon, that remarkable French saint, as he wanders the never-ending mountain roads of the valley. He is driven by the essence and force of this most remarkable environment. "Let the land have an effect on you," and its

strengths and rhythm will soon direct you, Reverend Boggs proclaims. "There must be born into a group the energy" and vision to make a better world with and for everyone involved in your daily sojourn, and those whom you know shall follow. This ideal was born into the Boggs family on the Laurel among the pines, and he tells you so.

As long as he can remember, the Pine Mountain Settlement School has had a trememdous effect upon his family:

> *My grandparents did washing and ironing, and that was the only cash income they had. Because there was no industry, it was a subsistence living. You could hunt some wild game—it wasn't very thickly populated—and get by with some garden produce, some dried pumpkin, beans, and apples. But the Settlement School had nurses and doctors that would give us attention and tooth extractions.*

Alvin Boggs has seen multitudes come and go from this school that gave his family life. They come thousands of miles just to breathe in the air that makes the sugar pine grow tall and straight. They dance upon its lichen boulders and drink its cool waters, then pass through the gate north and west. Crossing the small footbridge that leads into a glade, Reverend Boggs questions the direction they take as they leave the school. He worries that they were not touched as they must be, or they would never have gone.

In his office among reams of letters and literature, Alvin Boggs talks of his family and of the great strengths and weaknesses they possessed. Of his great grandfather, Will Blanton, Reverend Boggs says:

He had a very quick temper, and he wasn't very careful how he expressed himself. He would cut and shoot, but he was honest, absolutely honest, and people have remarked to me how he would feed his animals. Other people would let them starve, and he would overfeed his horse. If he thought you were unfair to him, you would be in trouble. He even pulled a judge from the bench in Harlan and stomped him in the courtroom with his big hobnailed boots.

Alvin Boggs

Alvin Boggs is a perplexing man because the life and death of his valley seem to revolve around him, and he must often feel the burdens of its inhabitants. He tells of carrying tombstones and the dead through the night over the mountains to their final resting place and then awakening early the next morning for a baptism. The pressures of so much life and death, of his responsibilities to God, of the administration of the school do not allow Alvin Boggs to rest. He shuns rest and is always upon another mountain.

You have to make do with less than other people in society. We had to eat anything we could grow; and if we couldn't grow it, we couldn't eat it. In those days you were poor if you had to have cornbread for breakfast. But I learned this: to make what you needed to live on, or you went without. There was a time when we would only go the twenty-three miles to Harlan twice a year, in the spring to buy the seeds and fall to buy shoes. We walked twelve miles to the train to ride eleven miles on it, then carried the groceries back. I can remember when a

31

head of lettuce was better than a candy bar. We ate it as a tiny piece garnishing potato salad. That was a treat.

Alvin Boggs is the complete mountain craftsman and has lived among the purest of mountain cultures his entire life. He learned how to converse with nature, to caress it for its secrets. He learned what was essential to survive. His feats of success against improbable odds when knowledge and strength worked together are the stuff of which legends are made. With eyes that have control over destiny, he tells the importance of trusting mankind.

Alvin Boggs was born and received his early schooling along the creek called Laurel. During his intermediate years, his parents followed the logging industry, living along the railroad tracks in shanties that were transported from place to place aboard a train.

The Reverend Alvin Boggs readily admits he had little formal schooling. He has learned his greatest lessons — nature's secrets, human psychology, divine guidance — not within the hallowed walls of the university community, but while in constant motion. He does not stand upon the mountain at night and cry to his God for guidance. He cannot be found alone among the glades, listening for the still voice of nature. He does not go to the greying professor for points of reference. He moves, and while in motion takes in all that surrounds him. Of course, the man learns and has learned in the academic community, and much of his life has been spent alone in nature; but the secret of his abundance must, in part, lie in his boundless energy coupled with a love for humanity taught long ago by his family. He is a man who sweeps up all who stumble in his path and takes them along with him. At eighty miles

an hour, with pressures too heavy for the mass of mankind, he can stop to shelter a flower in peril.

He read little as a child, for the only books that were available to him were those from the packhorse library, a circulating library brought up the hollows to the community on mule or horseback. The choices were not many the subjects were not inspiring, but he read stories of swarthy heroes, then went to the hills to live them.

Reverend Boggs is quick to note that his first seventeen years of life were not spent reading books from the packhorse library. In fact, he confesses to having been a hard mountain youth and having once run away from the school he now directs. Larger than most adults, he might well have been a model for one of those ruffians who show up in Jesse Stuart's tales of the plight of the early mountain schools when eighth-grade pupils were five years older than their teachers.

The only real joy he derived from his education through high school was singing, especially the Wednesday night ballad sings at the Pine Mountain Settlement School. And it was at one of those ballad sings that young, directionless Alvin Boggs was suddenly touched by human lyric:

> *In my high school I had been singing, and a lady who had been so wonderful to me asked if I would sing in an Easter pageant. She had been so nice to me I couldn't say no. I said, "We will even things up. I will sing for you this time, then we shall be even."*
>
> *At that Easter sing, there were ladies that had been there before from the Fort Wayne Bible Institute and a comparable institution. One said to me, "I heard you quit school."*

I said, "I did."

She said, "Oh! Sometimes things work out for the best."

That was all. I wasn't prepared for someone who agreed with me. Had she tried to persuade me, I could have argued. She then said that she was taking a group of children to another school I had heard about. She asked if I would like to go just for the ride. Well, I had never ridden in a car but once before. I had ridden in the back of a truck, the kind you have to push half way. It was a new car to me, a 1936 Dodge in 1941, and I would get to sit in the front seat for one-hundred and fifty miles. That car looked a lot better than that old bull we used to plow at home, so I said, "I believe I'll go." And that was when I was overcome.

Today, Alvin Boggs stands on the banks of the Laurel he loves so much, just above the waterfall he swam below in his youth, and admits that it has diminished as he has grown. The breeze starts up from the valley below and presses hard against him. Erect, facing the wind, just a little above the waterfall of his youth, Alvin Boggs is lost in its murmuring for an instant.

Alone in a field while breaking a young mule that had almost killed him twice, Reverend Boggs asked his Savior for guidance. Those voices from the school he rode to long ago in a '36 Dodge had reached him in that field over the mountain.

During World War II, he befriended many German prisoners, who still correspond with him. He learned to speak German by reading the most elementary books available, and the German prisoners told him he talked

like a baby. His humanity moved many of the prisoners, and he recalls their bringing him his rifle when he forgot it. During the Christmas season, he would shun the GI parties and go instead to the prison camps to sing with and for the Germans. His war experiences taught him that all human beings are precious.

Alvin Boggs began his tenure at the Pine Mountain Settlement School as Community Development Director and a teacher of woodworking. He has worked wood all his life, building homes and cabins, riving boards for shingles and fences, and has always riven the soul of his valley. When the great humanitarian and historian Burton Rogers stepped down as the director of the school, the board was not quick to assign Reverend Boggs to the post; but that decision had been made long ago, perhaps before Alvin Boggs was born, and today he directs the school he walked away from as a youth. In the forty-two years the Pine Mountain Settlement School has been in existence, Reverend Alvin Boggs is the first director to come from the community, a community nestled on the north side of three-thousand-foot mountains, often called the back side because of its remoteness.

There is no segment of the cosmos that Alvin Boggs has not touched:

> *Well, just like my neighbor the other day. He bought a mule at auction; and the first time he hooked her up, she ran away and broke the sled, and he couldn't hold her.*
>
> *The next day he said, "I'll sell her. I wish I could get my money out of her."*
>
> *I said, "Now listen to me, Larry. Don't do that. I'm glad you have something that has that much life*

in it." I said, "You talk to that mule and you tell her you are her friend."

He did, and she is one of the best mules around right now. I think that we need to have a relationship with animals that they will understand, as well as with people.

Standing above the small valley in which he was born, Alvin Boggs understands that his life has been of two states: for so many years he took, until he came to understand the importance of attempting to return some small portion of whatever he received. What a wonderful world he sees when man learns to return to the earth that which he takes away, lets the earth understand that his respect for it will endure! Several years ago at an urban workshop, when Reverend Alvin Boggs was asked what the urban community should do with the mountaineer, the displaced soul, he replied:

Now for these forty or fifty years you have taken our lumber, our timber in the rough. You have refined it and sold it back to us as beautiful desk tops and furniture. You have taken our coal, in the rough, and sold it back to us in dyes and paint and synthetics and tar. You have taken it in the rough and refined it and sold it back to us. You shouldn't complain if you take a few of the mountaineers in the rough. You should be willing to process and refine them. You should not ask people to bend to your notions. There should be give and take from both parties.

I don't appreciate it when people speak of mountaineers as isolated and set apart, as a spectacle, like a monkey in a cage. Mountain people have

quality inside. They have perceptions, values, that you will never find in an industrial area. You can visit with a neighbor; and if you have never met him before, you can be acquainted with him and feel a heartbeat. You find qualities that no classroom teaches. You get it from living. We are not just thinking of making a living, but of making a life.

Alvin
Boggs

Reverend Boggs hopes and prays that his valley will never become amalgamated like much of the rest of America. He feels it his duty to teach those who ascend the heights to traverse his valley what accord one finds when finally inspired by the scent of unnamed violets and the independence of the mountaineer. It is apparent, however, that the mountaineer must quicken his pace and become more political if he is to survive. Reverend Boggs has made sure that small groups exist throughout the mountains to aid mountaineers when no federal or state aid reaches the back side.

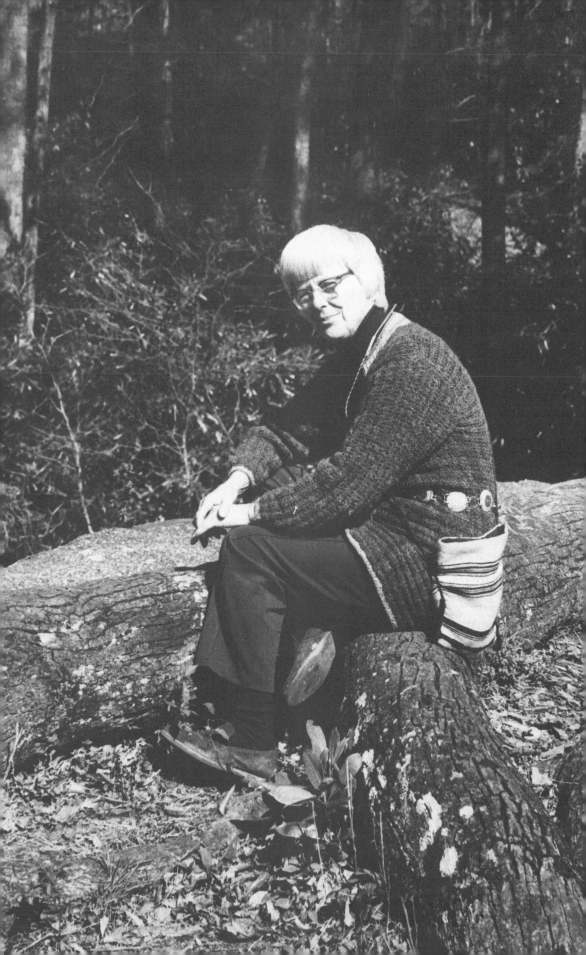

Huge Other Nexuses
Mary Rogers

*I*n the valley of the violets that have not been named, there dwells a woman who can name all those that have been. Mary Rogers is a lady, a spirit, at times almost elfin as she moves among the flora and humanity of the valley of the Laurel and the Greasy. There are few in the hills of eastern Kentucky who know the cycles of nature as this woman does, for she has lived within nature's doctrine and has applied it to the lives of all she touches.

She was born in England in a vicarage that bordered eight miles of unspoiled heather common and as a young girl spent hours alone moving quietly within the heather and moss. She vividly recalls the feel of the sphagnum moss on the soles of her bare feet.

The first nine years of Mary Rogers's schooling were accomplished at home under the tutelage of a governess. She was admirably schooled. Little of literature escaped her eye. She furthered her education in boarding school, then at Oxford, and finally, in London. She recalls that it was rather difficult for a young woman to be admitted to Oxford in those days. After Oxford she taught in India and China.

What brought Mary Rogers to the valley of the Laurel and Greasy Forks?

My husband and I both had taught, he in China, I in India, both of us in China among rural people. We were dissatisfied with the teaching of rural people in India and China where the school curriculum had nothing to do with the experiences of life, so when we got back here [America], we wanted to get to a rural school where the whole curriculum used the skills, abilities, and interests of the rural person as a medium for education. We were told Pine Mountain was the best place for this. There was a former pastor, when we were complaining about education in India and China not really hitting the rural people, who said he had heard of this school. It was the most imaginative work in education of rural children anywhere in the country and we asked if they needed us there.

Mary and Burton Rogers asked that question thirty-three years ago and today are still working under the shadow of the Pine Mountain.

Mary Rogers feels that country people the world over feel a kinship, one to another.

Wherever I have been, I have found that, having grown up in the country, no other person is foreign who has also grown up in the country—even aboriginal people in India. If the thing you love is to see how things grow and what things there are in nature, the cultural gap closes. Here I expect they thought my language was strange, but basically we were interested in the same things.

40

In spite of their years at the settlement school, Mary feels she and Burton still haven't gotten the vision across yet.

Mary Rogers

There was a group of us who knew what Pine Mountain must do to survive. I must admit that it was rather a hard road to get the vision over to people here. We haven't really done it yet. The staff and trustees had to be convinced. With acres and acres of land all around us being turned into desert, streams being polluted, false values coming in, legislation and lawsuits trying to change things, then the only possible thing is to change people's values. The things that money can't buy are the things you must preserve. You can only do that by education and will be lucky to be twenty percent successful, but you have got to try.

As a young girl, Mary Rogers was moved by the work of Beatrix Potter and began drawing at a very early age. During her boarding school days on the Yorkshire Coast, upon the cliffs that drop straight down to the sea, she drew. At Oxford, she readily admits, she could not concentrate on drawing, the thing she loved most, as much as she did on her studies. Yet, those Yorkshire cliffs have remained etched in her mind. Today she names and draws the violets of her valley. She has heard the murmurings from the thicket; she has answered with her pen and a very controlled British accent.

Mary Rogers has always created. By the age of twelve, she had read and had heard her father read most of Dickens and much of Scott. But as she read, she worked with her hands, the hands that today are constantly working on a piece of wood or with a lump of clay from the creek that runs before her cabin.

From 3,000 miles away, the drawings and handicrafts of Mary Rogers move the perceptive viewer. In their simplicity dwells a power of the creation of all things. Her sketches are simple and moving, yet so complete in their faith in the workings of God and nature (synonymous) that many have not seen but felt Mary Rogers alone upon the stream's bed. She is an artist who creates only from the vision and essence that has moved and directed her life. Upon the grounds of the Pine Mountain Settlement School, her works become icons.

Mary and Burton Rogers were married in India. She found the people of India warm and beautiful. She taught among the aborigines, not the classic Hindus.

There was something so genuine, people who loved to sing. They had a very simple, indigenous art, a very genuine art. When Allen Eaton returned from India, he brought two pieces of art from my tribes.

She tells of teaching mountain children how to live and work in an industrial society when she first came to Pine Mountain. Her returning students told her how important instruction in table manners had been.

It meant that, when they went to other places, they didn't feel out of place. They brought their courtesy with them and so they very readily adopted the manners. You see, the manners are just a veneer without the courtesy. But if you have the natural courtesy and are interested in how the other person is feeling, then these manners are useful little tools for bridging gaps between people, and the people value that. It meant so much that they didn't feel that everybody was wondering what they do at table.

42

Mary Rogers points out that, just as the school put the manners with the courtesy, so the school put the mechanical skills with the natural ability of the mountain children. That is what the first years of her experience taught.

She is a woman who loves the days of winter when the valley is covered with ice,

> *the day that the sun rises above the valley and you get the dark mountain and brilliance beyond any brilliance streaming from the top of the mountain. You don't want it to happen often because that heavy burden of ice breaks the trees.*

But it is so beyond anything you would expect from this world. She stresses, however, that all one really needs to do is wait for each season: they are all so moving, so meaningful.

Most of Mary Rogers's mountain neighbors do not share her view of nature; however, they converse with her about it. Explains Mary,

> *It matters to them. At least to the same amount as if you went to New York City and passed the El Grecos or something. Who would just see something with indifference? I guess there are those in the mountains who pass with indifference, but everywhere I've been, all the friends I've made—it matters terribly to them. Maybe holes in a rock that make little pools. This is a thing that they want to share, and it takes a long time, really; but as you go on, you find more and more how these changes in patterns in leaves, the water patterns, the flower patterns, the sky and clouds—how much it means to the people. They just*

feel wounded when they get away to the city, and they want to get back to the mountains.

Every instant of Mary Rogers's life instructs those who do not pass with indifference, those who take the time to dissect each daily encounter and experience in search of truths, ofttimes deep within each. It allows one to begin to learn how to look below the tinsel of any instance to seek out the forces that give beauty and truth to those who probe. Her home, office, presence, the continual motion are but a series of keys from which the perceptive viewer may learn. A vase of dried flowers, three smooth pebbles, a small, naturally dyed weaving—these are not a lesson; rather, they are the tools by which you learn the nature of all things. For Mary Rogers has not lost sight of her vision: she has actively pursued it from birth.

This woman who has spent over thirty years with many of the same people, traversing the same valley and hills, homes and roads, seeking nature's simple gifts, helping whoever needs that soft hand and accent, finds that her friends, these of the mountain, have not grasped and do not comment often on her artwork. Perhaps it is because they see the woman in perpetual motion, living and showing her vision to them in her every step and work upon the land. A sketch or bit of weaving could seem irrelevant to one who has stood upon the mountain with her or listened to her dialogue late into the night. While to others the same symbol may evoke a vision of epiphany.

Her home, a great mountain cabin, feels of learning and experience. Everywhere one looks there are little lessons on life and harmony. It contains a massive library on mankind and nature. Few books published on the nature of the southern highlands have escaped her library. She

shares her home with bits of each daily experience, little
gifts nature has given her, those little creations you stop to
pick up and put deep within your pocket to take out and
examine before your fire when you are home and quiet.
Most persons trample a good-sized forest in a lifetime:
Mary Rogers carries it home and shelters it.

She simply and matter-of-factly admits that most of her
deepest religious experiences have come from the woods.
Her school has changed from teaching mountain children
how to work and live in an industrial society to teaching of
and in the immediate environment. She explains,

> *Going out into the woods that have just been
> logged—woods more beautiful than I have ever
> known—and seeing piles of broken trees, smashed
> things that were beautiful, you realize that these were
> all the gift of love, and this is what man always does
> to love. He can't stand it. He always destroys it.
> Somehow, man has got to get to the place where he
> can treat love as a gift.*

It was Mary Rogers who said in 1973,

> *The weight of a world, dirty, damaged, depleted,
> despoiled, is on our shoulders. We wanted our children
> to enjoy it, love it, learn from it, live in it. What
> have we done? What can we do now? We must change
> our ways of thinking and of living, and our values.
> How?*

She and a group of very special people developed the
program that exists today at the Pine Mountain Settlement
School. They have begun to teach others the lessons of

years of rich humanity and at-oneness with the immediate environment.

But today the hills resound with the dirge of the depleted and despoiled. Within a mile of her cabin, the earth is being split asunder and carried away to distant cities. Mary Rogers is quick to point up that it takes between six hundred and one thousand years for one inch of topsoil to be created. Three inches can go in a storm. It won't come back. That which grows after the topsoil is destroyed is only scrub. Somehow, reclaimed land seems to lack the quality of the ages.

In discussing and creating her art, Mary Rogers stresses purity and utility. She feels that one should never be forced to create that which is foreign and opposed to his thinking. If one is not abstract, he should not have to create in the abstract for any reason. She questions much of today's pottery and ceramics, even though they are conceived in a true potter's fashion. In front of her fire, she tells us she enjoys some of today's grass-and-twig weavings; but they are not textiles, not honest textiles because honest textiles are cloth. She continually stresses self-credulity. Many potters and weavers do not create what they really wish to because they are afraid if they do not jump on the bandwagon, they will be thought inferior.

It is this jumping on the bandwagon, as I call it. Authors will not write a book that might be thought clean because they may be thought inferior. Many potters will not make what they would like to make because they may be thought inferior. Many textile workers will not weave a cloth because that is what other people have done and they don't realize they would get just as much from weaving cloth.

Too many have forgotten the joy of learning. It isn't something that one does just because he has to. Learning the joy of learning is in itself an art, she tells us, and it is well worth working for.

Mary Rogers

Mary Rogers talks the wisdom of ages, yet in preparing for her upcoming activities with her school, one knows she will be upon her hills and with groups that range from the mentally retarded to those sage-like in countenance and intellect. Spring is upon her mountains, and she is today upon spring, pathfinding for those who shall follow soon. She is only asking to put off damnation for love, and she is only using your earth to teach you. This woman, who has worked with the souls of the valley of the Greasy and Laurel forks for over thirty years without pay, asks you simply to weave cloth and make a small pot that holds water.

The whole of creation is mutually self-supporting. You can't tamper with a bit of it without upsetting huge other nexuses. Even a human being is a cosmos: you have all the bacterial world living within you. And right up to the nebular stars is this pattern, and to tamper with it, to dare to pull it apart for your own uses, is to me the only sin. It's misunderstanding the purpose of the whole thing. Love is the way. Put it on its lowest terms, the world succeeds, and then you go against it and you're breaking the nexus, therefore failing.

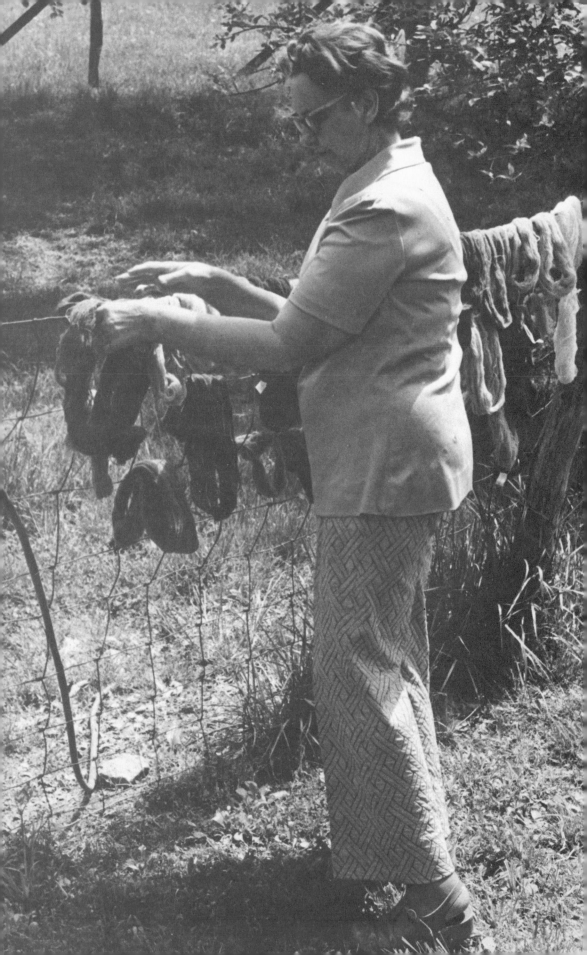

Those Who Have Clothed Generations
Edna Metcalf Patterson

The Greasy is a creek a little more intense than most. Its growth has always been checked by the slope and ruggedness of the terrain it cascades through. Along its banks, stories are told of times when great men of the mountains would wrest enormous logs upon its waters to the middle fork of the Kentucky River far below. In the valley of the Laurel and Greasy, the eyes of those who witnessed the release of the timber from the lake a little below the Adrian Metcalf cabin, when the key in the splash dam would be pulled and man and nature would often struggle to the death riding the Greasy, grow wide with respect and pride of those times.

Upon the banks and the slopes of the mountains above the Greasy, the flora is abundant, and at this altitude colors seem purer than elsewhere. Spending much time in the forests of the Laurel and Greasy, one learns to paint from the master. For those deep within the forest, the brush moves daily across the great landscape.

As in all environments, nature has the upper hand in decorating. In the hills of eastern Kentucky and the rest of the southern highlands, there have lived those who, for many years, have used nature's pure colors to dye the clothing they wear. They have clothed generations in fabrics colored with the dyes of the mountain.

One who has been upon the mountains gathering the roots and barks, weeds and petals to create color as close to the natural as nature itself will allow is Edna Patterson. For over fifty years, she has collected the broom sage on both sides of Pine Mountain and taught her dyeing processes to all who desired to learn.

Edna Patterson is another of those children of great pioneers who has been directed to share with others all her life. When she was nine years old, she stayed with Katherine Petitt at the Pine Mountain Settlement School and was touched by the grandeur and grace of that pioneer educator. Today Edna Patterson still hears the voice of Katherine Petitt as she did when they traveled the valley of the Laurel and the Greasy together.

Before her sixth year, Edna Patterson remembers traveling with her mother and grandmother upon the mountains and creek bottoms of the area around Little Laurel, just off the Greasy Branch, in search of the materials necessary for dyeing the sweaters and socks and blankets and shirts of her family. Edna Patterson is one who has gone to the very heart of nature for over fifty years to seek out the essence of color. She is very quiet and speaks only when spoken to.

My mother and grandmother both did natural dyeing for home use. When I was growing up, I can remember going with my mother out to gather things to dye yarn for our home use. I didn't dye then but would go out with my mother and gather the things and materials we needed. I was always beside her as she dyed, and I remember the things that she did. We didn't have all these things we use as mordant now. Then we used vinegar and salt to set the dye. As I grew older and became connected with the Settlement School, they did vegetable dyeing.

50

Edna Patterson began weaving at twelve years of age at the Settlement School. In the early 1920s, Ms. Pettit had a small amount of business associated with the weaving at the Settlement School, and Edna Patterson learned from a weaver known for producing fine cloth. Today, Ms. Patterson's fine linen napkins and place mats exemplify years of weaving fine cloth. Each piece of her weaving is the product of over fifty years of gazing into earth's bosom for its hue and fifty years of creating cloth to keep a child warm and put a shirt on a man's back.

Recalling her mother's preparations for dyeing and some of her process, Edna Patterson shares more of the heritage that nurtured her growth in the study and application of natural dyeing:

Edna Metcalf Patterson

> *We would gather for whatever color my mother had in mind, mostly brown from walnut bark. Hickory bark would dye greenish yellow; sumac berries would be red looking. A lot of times she would knit brown socks for the boys because they didn't like the bright colors then. If they wanted a real dark brown, she would collect the roots of whatever bark she was using, like walnut: the roots are a darker brown, and the hulls of the walnut are a lighter brown. Three shades you can get from black walnut.*

She always warns those she teaches: when dyeing with natural materials, you must dye enough yarn for the entire piece. In nature there is no duplicating, and the dyes from two different black walnut or oak trees are never the same.

In fifty years of dyeing, Edna Patterson has experimented in all seasons, but summer, when the sap is up, yields the brightest colors.

> *I think in the summertime when the sap is up you get more brighter shades. I've tried it all times of the*

year. Sometimes I've used leaves of the trees like beech, and I use the leaves of rhododendron for grey. You can gather them anytime. I think they are prettier in the summer.

When this great student and teacher of color and weaving allows herself to muse upon beauty, her vision is always of the north side of the great Pine Mountain in autumn as the millions and millions of golden leaves blaze in the sun. She has lived close to the sources of all colors of the valley of the Laurel and Greasy for over sixty years, yet the great golden mountain in autumn stirs her to this day.

When preparing her dye outside, Edna Patterson uses a great cast iron kettle for roots and bark.

I have a big cast iron kettle. You take your roots, put them in the kettle with water, and boil them. The longer you boil them, the stronger and darker your dye is. Then you dip out your roots and all the fiber you can get out. Then have your yarn wet and put your yarn into the hot bath. Boil it as long as you want. The wool absorbs the dye quickly, and it doesn't take very long. You don't bring it to a rolling boil, just sort of simmer it. Then you bring it out, rinse it until the water is clear, and then hang it up to dry. That color is fast. It doesn't fade or lose its color.

It takes about an hour to boil the roots to the strength you want. Sometimes, if you want a real dark, almost black-brown, you put in coppers. Take out your yarn, sprinkle in the coppers, and let it dissolve. Then put your yarn back into the dye bath, and you have a real dark brown. If I were using hickory bark, which makes a yellow-green, I would sprinkle in some coppers and put the yarn into the bath and have a green. If

I were to use alum, it would make more of a pastel as a mordant. It does take experience. Every tree I have ever used in dyeing makes a color. I haven't tried them all, but all that I have tried do make a color. I have also found that, when drying the yarn, sunshine just brightens the natural color.

Though Edna Patterson is a craftsperson who has dedicated herself to creating with utility as the sole purpose, she has experimented with many color sources, including sawdust:

I don't know of anybody who has used sawdust. I really don't. I just experimented with it. I got a color. It is fast because it is from the black walnut wood where my husband was making a dulcimer. It made a color about the same as walnut hulls, light brown. It was very easy. I gathered up the sawdust and tied it into a cloth so it would be easy to lift out of the water. I was very pleased with the color I obtained.

Among the plants, barks, and roots Edna Patterson uses most often in her dyeing are: the cocklebur for tan; the marigold, gold; hickory bark, greenish yellow; sassafras, peach color; cedar root, violet; smart weed, chartreuse; jewel weed (touch-me-not), tan; and dahlia flowers, a very light beige. As mentioned earlier, the walnut bark, root, and hulls yield three different shades. From the mountains the sumac leaves dye red. In Edna Patterson's hands, these colors have all been refined to their purest state. The yarn and cloth she dyes are always exquisite. Once again, we find a woman who has dedicated her life to looking into the very heart of nature for its creative energies. Her work possesses a delicacy far beyond the results obtained by others who create with that which is not natural.

Edna Metcalf Patterson

53

Edna Patterson was, of course, an integral part of the weaving industry that the Settlement School perpetuated for those of the Laurel and Greasy Fork Valley. The weaving done here during the late 1920s and early 1930s was as fine as any in the country:

When Mr. Marsh was the director, the girls did weaving as their work at school. They had to work so much during the week. They had sales for all the weaving they would make—blankets and coverlets, curtains, and place mats. I was working int he weaving room, helping to fill some orders for blankets. That was in the 1930s. In 1926 I went to Berea [College] and worked in the weaving room. I had never gone to school to learn weaving. I'd been in the weaving room since I was twelve and had been taught to weave.

Looking at the fine work produced at Berea College and the Settlement School in the late 1920s and early 1930s, one is overwhelmed by the delicacy and craftsmanship displayed. Perhaps nowhere else in the United States was finer weaving done for public consumption than in this environment during that era. Edna Patterson and her sisters from the valley of the Laurel and the Greasy learned from extraordinary master weavers. These were women creating cloth for the sheer beauty of creating cloth—cloth being one of mankind's more important creations. Edna Patterson has always lived in this environment where cloth has more majesty than classical sculpture.

When talk turns to the pace of the mining industry in the mountains of eastern Kentucky, we hear a slightly different tone in the soft voice of this woman who has lived so close to her earth for such a long time. Edna Patterson senses something amiss about the unchecked industrial thrust into the Cumberlands:

I am not at all pleased with them tearing down the mountain and doing strip mining. I think that really does destroy the beauty and the timber. There is certainly a lot more traffic in the mountains lately, mostly coal trucks, often taking the road.

Edna Metcalf Patterson

This quiet woman who carries the vision of the north side of the great Pine Mountain in the autumn's exactness with her, who has lived a life remarkably in harmony with her environment, is more than a little concerned with the rate at which her mountains are being developed and stripped of all semblance of more harmonious times. Yet, she still creates chartreuse from the smart weed as her husband sculpts the walnut.

She also feels that with so much money being poured into the mountains of eastern Kentucky, some funds should be directed toward proper development of the great natural resources of the land and the people:

The people in the community? Oh, there may be one or two that are selling minerals and coal that are getting money. Other than that, it's the people coming in that can afford to buy those big trucks and someone who is paying to have it hauled out. Little money stays in the community.

Today, when she is asked, Edna Patterson travels with her husband to the small summer festivals in surrounding counties to teach the children from the vales and glades of eastern Kentucky much of their heritage in action and word; but the Pattersons' vision shall always be of the north side of the great Pine Mountain covered by the golden mantle autumn weaves.

55

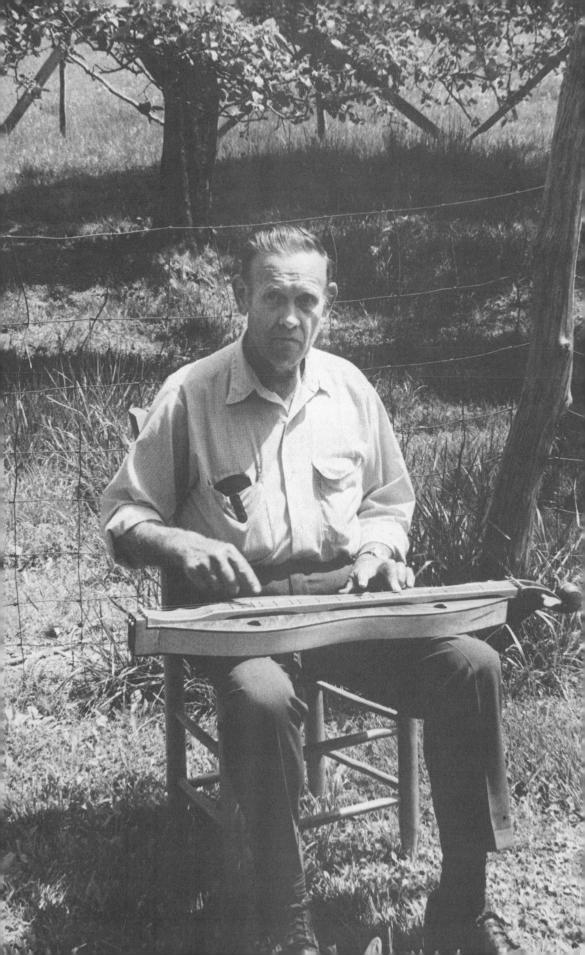

A Quiet Voice
Jess Patterson

High in the mountains of the southern highlands there exists a quiet voice, a soulful voice that captures the moments of pure harmony that play deep within the person who listens to humanity but rarely speaks. It is the voice that has always been the clearest when one is alone. It is the voice of the ages, which has crossed the great ocean and found rest high in the hollows and glades of the region known to most as Appalachia.

One who has listened to that voice for a lifetime, who has captured that voice, is Jess Patterson. Like most from his community, he has lived on one or the other side of the same mountains for his entire life, rarely traveling beyond them. He will tell us he has no idea where he found this voice and won't readily admit to its existence until he moves his ear close to the heart-shaped sound hole of his black walnut dulcimer and gently draws the melody.

Thousands of miles from his hand, Jess Patterson's dulcimers have brought tears to the eyes of careful listeners. The mellow harmonies of mountain dulcimers continue to move one more deeply and more permanently than those of their mail-order relatives.

Jess Patterson's has not been a life of sallying blissfully through the hollows and valleys of his native mountains.

As a young man, he did not sit before the fire and serenade his wife and children with ballads upon his instrument. He will be the first to admit that his life has been more labor than melody. For a short time he may have those who listen believing him. But suddenly, when he lays his dulcimer aside and begins to converse, a greater melody is discerned.

Until recently, Jess Patterson would daily traverse Pine Mountain, which is one of the great teachers of song. He would arise before the sun to feed his animals and prepare for his trip to the Settlement School, where he has worked for over twenty years and with which he has been associated for most of forty. Daily he would follow the sun up over this mountain. His truck would move at ten miles an hour as, much the same as a sailboat against the wind, it tacked the mountainside. At ten miles an hour, the rhododendrons become majestic in the morning's first light, and the dogwood is never out of sight. From the top of the mountain, looking into the Valley of the Cumberland draped in the mists of an early summer storm, simple strains become symphonic. Descending into the valley of the north side, through those mists, the symphony gives way once again to the simple melodies of a day in that vernal valley. Perhaps it has been that trip which has moved Jess Patterson to place that small voice in the soul of his dulcimers.

As Jess Patterson moves across a field, his motion is that of the present, never hurried, as if the tender fingers of nature carry him along steady and always under control, rarely coming to rest. It is his tempo that has taught him part of the song he places deep within his dulcimers.

His gentle manner and remarkable blue eyes hold one transfixed. His speech is controlled and very low when

talking about himself, yet it contains a distinct harmony and unceasing rhythm fostered by his joy in most of what he does. It is a voice that was deep in the earth digging coal forty years ago. It is a voice that has been across the mountain and upon the valley floor, that has spoken into the winds of winter and with the breezes of spring and has found the same joy in each.

As a young man, Jess Patterson worked the coal of Harlan County. He worked hard at supporting his young family and had little time to craft the walnut he now sculpts. It was not until he began to drive the first school bus at the Pine Mountain Settlement School, a truck with two seats, that his interest in wood began to grow.

Jess Patterson

> *I lived down by Little Laurel and would walk three miles to the school and drive the school bus, wait around for the afternoon to drive the bus again, then walk home in the evening. The director said, "Jess, why don't you go up in the wood shop and make something?" Well, Boone Callahan was wood shop boss. I went up and talked with Callahan and I was watching them and I asked if I could learn to make something. They taught me to turn on the lathe and use the tools. It was a great help to me. I do it yet.*

Jess Patterson never left the influence of the Pine Mountain Settlement School. He would quietly work up and down the creeks called Laurel and Greasy and Issacs', plowing the small mountain farms of his community for such a nominal sum that it could only be called community service.

> *Talk about the school helping. I would take the tractor and plow those gardens and fields up and down Greasy and Laurel at two dollars an hour for a big*

59

tractor and two plows behind it. Is that a help to the community? Maybe I could plow three acres a day. We would go way down Greasy, every place you could plow with a tractor. That was a help to the community. You can't beat that.

While working upon the grounds of the school, Jess Patterson began to find a fulfillment he had not experienced before. He was allowed to develop his woodworking talent at his own pace while helping to maintain the farm and work upon the magnificent architecture of the school. Jess Patterson worked on the tables the great pioneers of the school had constructed before and learned from them the importance of durability and endurance. It is an environment where nothing is ever wasted and the beauty of things natural is stressed.

Experiences such as riving the boards for reshingling the oldest log cabin in Harlan County, located upon the grounds of the Settlement School, helped tie Jess Patterson to the history of his immediate environment and taught him lessons vital to his creating.

I didn't rive any boards after I came to Pine Mountain. We made boards up there to cover those buildings. I had seen people do it. This board would get to running out you see, and they would turn it over and press the other way and get it straight. One thing is that you must have some pretty good timbers. They have to be straight or they won't rive naturally. To cover old logs down there, we went way up into the mountains, behind the school, and hauled them out, these blocks, you know. We would take a froe and split them up.

In looking into Jess Patterson's eyes, the color of endless blue springs, one gets the distinct feeling this man may never have closed them to any circumstance in his life. In fronting each instant and rising above it, he has learned an inner peace that is found when listening to his instrument.

Upon his farm he moves with the same flow as in younger days. Nature does seem to direct his motion, whether he is tilling the ground for a small crop or moving high upon the hill among the poplar and beech. Like the man himself, the farm has been directed by an intelligence beyond most. Only much learning at a controlled pace could create the ease and order his home and land manifest. He will tell of the importance of the different grasses that grace his pastures. He is aware how often the different earths his acreage holds must be turned, treated, and worked. It is a relatively new farm to him; but in the few years he has been upon it, he has transformed it into a world of harmony. Each individual aspect nurtures another. There is no waste, and though civilization presses heavily upon his land and person, the voice of the traditional mountain dulcimer still rings clear as he plains the walnut or goes to his smokehouse for country ham.

Like most mountain farmers, Jess Patterson prefers the spring to all other seasons.

I like the spring of the year the best because everything looks as if it is coming to life. In the fall of the year, it looks like it's done everything it is going to do. You see these here things jumping up out of the ground. The trees turning green, like life is coming into things. In the fall of the year, the cold winds begin to blow and the leaves look like they are dying away, don't it?

Jess Patterson

61

Jess Patterson has made over five hundred dulcimers. In a region once famous for this instrument, he may be the only such craftsman. He sees others at fairs and mountain festivals, but they are few indeed: the dulcimer has moved to lower climes and younger generations.

He learned to make the dulcimer from another at the Settlement School, a man younger than himself. Jess Patterson's skill as a woodworker was already established, but he wasn't aware of the melody he carried within himself until he first strummed "Wildwood Flower" and "Barbry Ellen." In talking of his dulcimers, he tells of the woods he feels are the most harmonious, those he most enjoys working.

> *I like black walnut with a butternut top, a soft white walnut which we don't have much of—very scarce now. We call it white walnut here. I think they have as good tone as any of them.*

He makes the three-string dulcimer using five-string banjo strings. Unlike most dulcimers, Jess Patterson's are designed to allow as little retardation of vibration as possible. He understands the importance of not impeding the flow if sound is contingent upon vibration; he elevates the fret board as much as possible above the face and sound box of his instrument, allowing for more vibration.

Jess Patterson allows nothing to stand in the way of creating in his dulcimers the most perfect harmony he can, both in melody and appearance. He will go to great lengths to smooth a knot in wood he finds aesthetically pleasing. He goes to the heart of the tree for the most beautiful and expressive wood, to the soul of the man for the most beautiful and expressive melody.

Jess Patterson does not use the tools of his youth in creating his instruments but most certainly uses the skills and vision:

You don't know what is in the wood or tree until it's cut up. I look for the dark in the walnut wood. I don't know that it makes any difference or the dulcimers any better. I like the color of the dark walnut wood. You cut a tree up here down and take it to the sawmill, and they cut it into board lumber. You can't tell what is inside it yet until you cut and plane it down.

I sand the wood to about an eight of an inch. I use a floor sander now to smooth it down. I cut the sides about an inch wide with a saw, then sand them down until smooth. Now I have the top and bottom and sides rough cut and sanded down. Then bend the sides to curve round. Then glue the sides to the bottom and fasten them with a C-clamp. I have a form it sits in now. I make my frets out of nails, hand carve the pegs, carve the head. The nails are eight gage about one and one-half inches long. Sometimes I have to file them off a little because the string hits on them. I learned over at the school to use the heart-shaped sound holes. That is roughly how it's done.

Each one has a different sound. When I first started making them, I could hear a different sound in each of them. I don't know whether it's the time I put in it or the wood.

Those who journey to his farm to listen to Jess Patterson play his dulcimer or explain the massive walnut tables he makes find their perceptions altered. They begin to look a little closer at the small knot in the dulcimer.

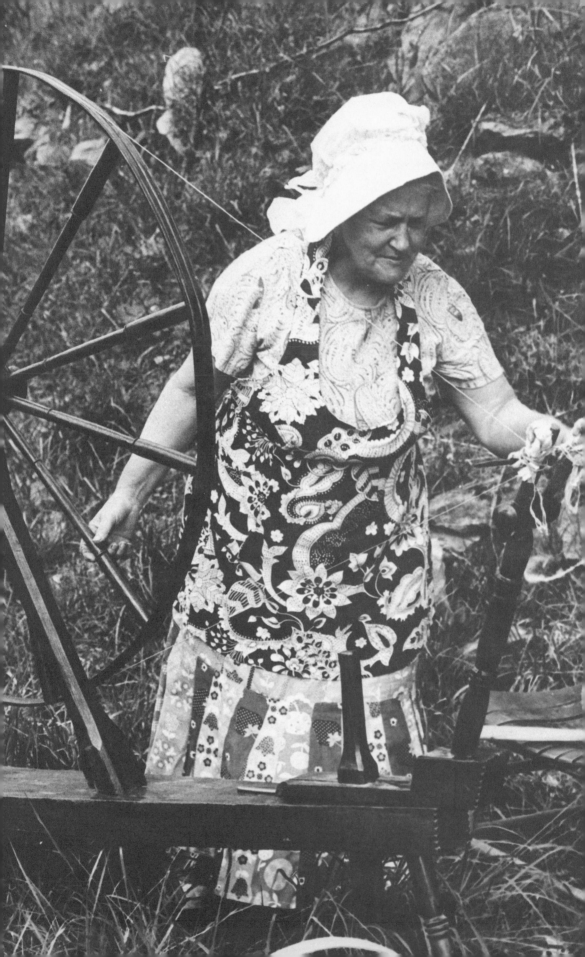

From the Mouth of Spurlock
Sarah Bailey

She was born at the mouth of Spurlock, this woman who may just be the most remarkable craftsperson in the southern highlands. Her hands, though scarred and bent from years of caring for others, spin with what she admits is magic. No other word is adequate to describe the talents and accomplishments of Sarah Bailey.

Today, she lives not far from the mouth of Spurlock. She remembers boarding the men who built the road that brings neighbors from near and far to her door — for buttermilk, for country butter or a cornshuck rug, for cornhusk flowers, or for a quilt to cast off the chill. For Sarah Bailey does feed the hungry, clothe those in need, give directions to the lost. She is a woman seldom alone, for she is beneficence personified.

The cabin that once was her store, before her big house burned down, is usually cluttered with people or her art. Like most cabins in the hills of eastern Kentucky, one finds it low and perhaps a little dark, dark because the morning sun reaches into the valley later than into most other areas and retreats from it much sooner.

It is a sultry day. The wasps of spring float gently about Sarah Bailey's door, undisturbed. An occasional coal truck passing very close rattles the front door. Over the crackle of bacon and salt pork frying in a massive

skillet, Sarah Bailey calls you to the kitchen. She wants to tell you the story of her hands.

When she was eleven years old, she remembers, she made her first cornhusk rug, woven from the husks that most discard. She had seen a rug that another had made and told her mother that, to make money, she would make one like it. Sarah Bailey readily admits to being "gifted minded" from her birth. That first rug, and many that followed, she sold to Katherine Petitt, the major early influence at the Pine Mountain Settlement School.

The bacon sizzles as Sarah recalls making the first cornshuck doll she ever saw:

This was back in what you may remember was Hoover's days. We were having an awful hard time, people was, about money. Mrs. Ellis Cobb that was at the Pine Mountain Settlement School, she wanted to help me. She knew I was ambitious and I wanted to do things. She said, "I wonder if you can do something with cornshucks? You make beautiful rugs. You reckon you can make a doll?" Well, I studied and studied. I came home and made forty dolls that brought me a dollar apiece. Oh, was I tickled! That was back when money was money. I got into angel making then, and cornshuck birds.

As a child, Sarah remembers being directed by the fall:

When I was little, I loved to see fall of the year come because I could pick up chestnuts. We had lots of chestnuts. It just always tickled me to death to see fall of the year come. I really loved to get out and pick them up and sell them. You see, I would get a nickel a pint, and oh Lord, I thought that was big money.

66

The singing pork is being replaced with potatoes. Their lyric is even more pronounced. In tune with the rhythm of her stove, Sarah tells what it is all about, the mountains that still move her:

Sarah Bailey

> *I love in the mountains because the air is fresh. You have fresh, free air; and if you work, you can grow something to eat still.*

Talk turns to her abilities at bottoming chairs, for she has gone to the mountain for hickory bark to weave their seats and backs. She says the bark peels easier when the sap is up. And the magic of her hands is apparent as they expertly slice another potato.

Sarah is a short woman, built closer to the earth than most. Perhaps her short stature affords her more mobility, for she is in perpetual motion.

> *I was never a person to sit down and wait. All my life I always wanted to see what I got. You know, I've washed on the board for twenty-five cents a day just to make a little money, rather than sit around without anything. I could get material then for five cents a yard and did my own sewing. When I married my husband, we had one dollar and twenty-five cents between us.*

There is no question at all that the Pine Mountain Settlement School has had much to do with Sarah Bailey's life. Early in its life, its great men and women taught Sarah Bailey her importance as a human being. More recently, its great men and women have been taught by Sarah Bailey and have been reminded by her of their heritage. She describes the school's early days:

When they came here, Ms. Petitt had farming going on. She had a boarding school for the boys and girls here in the valley. She taught the girls how to do things, how to help their mothers a lot. I just think it was a wonderful place.

Though Sarah Bailey spins at Pine Mountain several times a year, talk returns to a time in her youth.

When we were little as children, there were eight of us in all. Instead of us having television to watch, we would sit down and pick wool or we prepared something to be canned to be put away for the winter. We worked. We would take walnut roots and make the nicest black dye you ever saw. We would take black walnut bark and make brown, and hulls dyed brown.

Sarah Bailey's great gift and love has always been spinning with her magical hands. Spinning is one of the major harmonies in her life today, as it was to her mother, Melissa Jane Curry, many years ago.

I just love to work with wool because, when you take your own sheep's wool and card it and spin it, you know it is all wool. Well, you can weave that into cloth or knit it into sweaters or socks or house shoes. So many things it's useful for, and you can say that you brought it all the way from the sheep's back. You don't say, "I went and bought this at the factory." There is just a great joy, and people love to spin. The more you spin, the more you love it. That was one thing that kept my mother happy when she was young. I can remember coming home from school

and hearing my mother a-singing. She would be *a-spinning and singing to the wheel, and that old wheel* *would go woo, woo, as she would spin. Sometimes I* *get that sound in my imagination. She would sing hymns.*

Sarah Bailey

Sarah Bailey does not have much time to talk of singing. She returns to talk of the work, hard work, her life has known perpetually.

There are so many people in America growing up *who do not know A from how to work. They know* *how to read things from books, but they don't know* *how to work. I do think more people should come* *back here to learn how to work because we don't know* *what we are going to have to do before we die. We may* *have to go back to some of these crafts before we die.*

The formula and magic of her valley are easy for Sarah Bailey to tell, for she has known nothing else:

Living in this valley is hard work, and we have *always loved whatever we have done. The Lord* *has prospered us. We have been people who love to* *work with our hands and create things, and the Lord* *has been wonderful to us. We have always loved* *whatever we have done.*

The stove is suddenly silent, save for the slow perk of a large pot of black coffee. Everything Sarah Bailey does is with strength. The table at which you sit begins to fill with the bounty of Sarah's stove.

This is green beans out of my garden. These are *soup beans. This is apples I raised in our orchard.*

*These are fried apples. The pork and beef is raised
here. Country butter. I apologize for the cornbread.
Sweet milk, buttermilk I churned, beaten biscuits.*

Sarah recalls having biscuits only once a week when she
was growing up. Then, all food was raised at the mouth of
Spurlock.

Sarah Bailey has just fed you with the labor of her
hands. Now she begins to feed you with the labor of her
soul, for this lady of the mountains, in her great wisdom,
has helped organize those of her community not driven by
the same love of life.

There are few items in the annals of pure handicraft of
the southern highlands that this woman has not made. She
has used natural dye processes all her life. Willow,
honeysuckle, white oak, and hickory baskets have not
escaped her creative powers. Sarah Bailey has whittled
scrub brooms, made storybook dolls, and knitted hundreds
of garments from wool she has taken from the sheep's
back, carded, dyed, and spun into yarn. Her living room
contains two looms and two spinning wheels. She tells of
braiding a cornshuck rug:

*I braid them with three braids. Each time I come
around her, I add one shuck. I can make baskets
out of cornshucks. I set this ole iron here for weight
to hold the shucks down and see, if you shuck it too
large, to tear it off to make it all even. You have to
keep it all the same size. I save shuck by shucking
in my butter loft and saving them all year. You have
to keep them in a dry place, but dampen them when
you are using them. Now in working with shucks,
you can make a beautiful flowers out of them by using
the natural color. For this rug, you start with three
shucks eight or nine inches long. As I braid through*

them you see I tie them together. You can even bottom chairs with these. I just start braiding the three eight-inch shucks, keeping them moist, and braid, in a circle. Then run heavy string through them to hold it all together. It's good to put a little shellac on the rug when it is done.

Sarah Bailey

Because she has learned how to accentuate the natural colorings of the shuck, Sarah Bailey's finished rugs are works of art.

This woman, who never really rests, recalls those moments in her life that are the most meaningful. A true, simple, pure picture of the essence that directs her life:

> *About the happiest time for me is when I have a nice crop a-growing and see my beans and corn a-waving. I just feel so good knowing that I am going to have a good crop. Then I know I can use the fodder to feed the cattle and also I save the shucks to make money with so it is all of a use. My beans, I can raise, can, and freeze them; and if I have more than will do me, I can sell a bushel. I love the fall of the year when the trees get to being every color, and then it makes me sad to see that soon they will all be gone when the frost comes and all will be naked again.*

The wasps of spring have vanished as a storm moves up the valley. The breezes waltz the young leaves, but all is dark and ominous. Sarah is working on a cornhusk rug, telling of someone from Berea College who is coming up to document her spinning. She turns to talk of her method and describes to you at length how she cards and dyes, her hands in constant motion. They are magic and beneficent hands that are now growing a little tired of caring for all, but will continue.

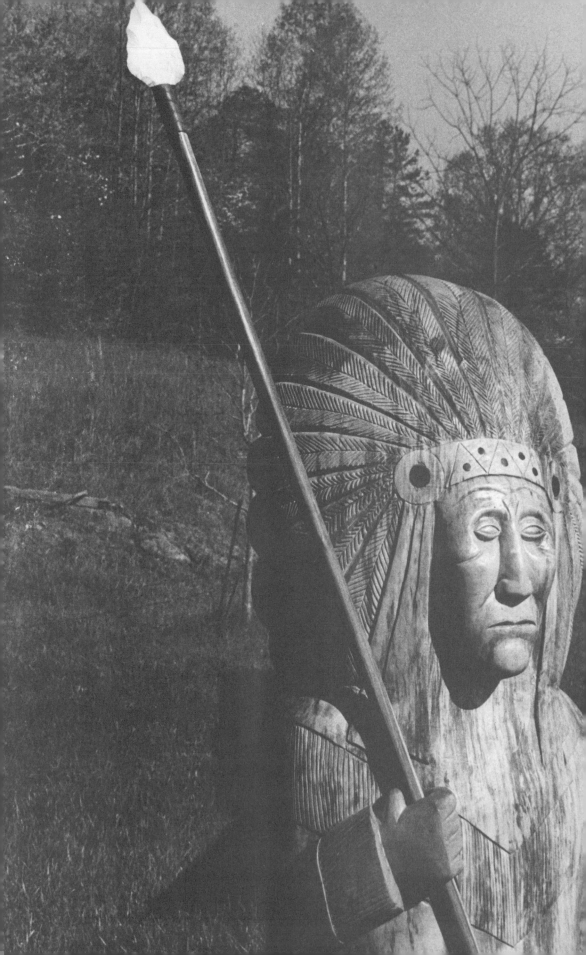

A Little to the West of the Great Mountains
Ed and Pansy Cress

A little to the west of the great mountains, nestled in the gently rolling hills of eastern Pulaski County, Kentucky, live Ed and Pansy Cress.

At night they have been lulled to sleep by the song of the Line Creek that flows gently through their yard, the creek that has rejoiced at the births of each of their twelve children, the creek that the Gentle Whittler, Ed Cress, follows across his land in search of native wood to fashion. For Ed Cress is, perhaps, the finest whittler in the southern highlands. Certainly, he is the boldest.

Ed Cress lives on a country road that flows with the creeks of his county. In the spring, you will normally find him at home. He is retired now and spends the days with his wife and knife, a little sumac and a lot of buckeye, creating works from the wood that grows on his land or not far off. Members of his family tell of his doing a little whittling when a boy, but he is a man who discovered a gift when most retire. He has always known the story of the wood, for his entire life has been spent in intimate association with the forests of his county. He has always been aware of the workings of the wood and its murmurings so it is not difficult to understand why his are the most beautiful wooden Indians carved in America.

His father was an old country doctor who rode a horse all over his end of the county. J. A. Cress administered to the sick of his county for forty years and raised Ed within

five miles of the farm on Line Creek. Ed Cress can remember his father being gone for two weeks at a time during the epidemic of 1918. J. A. Cress would be gone for a week, then ride up to his farm, tie his horse, come in for medicine, ride off, and be gone for another week or two. His father is a legend among those in the county who still remember him.

As a young boy, Ed Cress was educated in a one-room country school three miles from his home. He showed enough aptitude to go on to college and even taught when he returned from two years there, but he soon realized he could not raise a family on a teacher's income. Today, his voice is that of a forceful teacher. He has learned from his father to answer when called.

When he was small, no coal was mined in his county. By the time he was eighteen, only enough coal was being mined to meet the fuel needs of people in his community. Shortly thereafter, a small amount was shipped out. Ed Cress feels there is a place for the coal industry in Kentucky. There has to be.

But Ed Cress has learned to love the wood he whittles and is aware that someday it may be gone. While he isn't one to make an impassioned plea for the preservation of the forest, his county, and the world from the ravages of strip-mining, it is obvious that he understands more harmony must exist between the coal operators and the land. He feels that you must, in some small way, repay nature when you take from it.

Ed Cress's skill with wood is self-taught, perhaps inborn. As is true of most mountain women, his mother's hands were seldom idle, she made quilts, working with fabric, not wool. The busy rounds of a country doctor left his father no time to teach Ed how the bark should be peeled, how to know when the sap is up, and how to follow the grain. Indeed, it was almost by accident—or providence—that he began to whittle.

I was working for a coal company over here on the Cumberland River. I was loading barges. They was running a double shift at the mine, and I started work at noon. Then loaded a barge in whatever time it took. We worked sometimes to midnight or one o'clock until we had enough coal to fill the barge. I was down on the lake by myself just watching the machinery work, and I found a big old cedar stump on the bank and, of course, had a choppin' ax with me and cut me out a hunk and started whittling. From there I just kept doing it. Then I had a little gun, a little, feller, that I kept with me. They had rattlesnakes, bobcats, and this and that over there. I was down a mile from the mine, so I kept this gun along and I made one of them. I made a hammer, gun, and horse and cart from the first cedar wood.

Ed Cress enjoys whittling horses more than any other object. He isn't certain why; but having had a father who was a doctor on horseback for forty years, he has always been acutely aware of them. He says that whittling horses is not good business because those who buy his carvings are not overly moved by horses, but he loves the lines of the animal and the challenge of whittling the muscle tone to correct proportion.

Ed Cress has carved fourteen wooden Indians of marble-like buckeye wood. He chooses buckeye because of its unique coloring:

The color is the main thing that caused me to use buckeye in the beginning. Poplar is just yellow; walnuts, brown or black. Buckeye is many, three or four of these colors, and is more interesting. When we found it was a good carving wood, we went to carving everything out of it.

Ed & Pansy Cress

75

When exploring the hills in search of the proper wood for his Indians, Ed Cress moves slowly and comfortably, learning from nature and his wood, listening and watching its movement.

You don't need to cut into the log because you can pretty well tell what's in there by looking at the end. For the Indians we make, you need a log eighteen to twenty-two inches wide. Usually when we get a tree, you can just chop the bark off and just peel it back. We use a chain saw to get the log to size. Then a choppin' ax to work on the outline. I have just a regular old choppin' ax with a short handle, and we start hewing after we do our outline. You can get the thing into a pretty good shape with a choppin' ax. We have these old-time hand axes too, and then from there it is chisels and an old tool they used to call a spoke shave. Blacksmiths used it to make wood wagon wheels. We use that for smoothing up. We have had one for years. From the time you peel the bark, we could maybe do an Indian in four months.

When Ed Cress talks about his family, his voice sounds with laughter. He tries to recall how many grandchildren he has with twelve children all still living. He looks at Pansy for support, and she tells him there are fifty-one in his family now. As grandchildren move in and out of the room, he tells more of selecting and preparing his wood:

Before the leaves get grown on a tree in the woods, if you would cut your buckeye down and leave the top on it, peel the bark off the body and leave the leaves, the leaves before they dry away and die, they will draw a lot of the moisture out of the logs; and when they do that, they are almost ready to go to work on. If you leave it laying this way, it tends to get the dark color, when it is normally white.

76

Ed Cress's eye falls on three trees that stand beside the road fronting his farm. They are massive sycamores, two healthy and reaching heavenward, one dying. He has lived with them for many years and does not intend to let the vision of the dead sycamore mar his view. He and Pansy plan to top the dead sycamore, build scaffolding roughly ten to fifteen feet above the road, and carve about seven feet of that tree. It will be their monument to the self-taught whittler.

Years of hard work have taught Ed Cress the importance of mastering his tools rather than letting the tools master him. The most important tool to the whittler is, of course, his knife, of which Ed owns more than fifty. He knows his knives by heart, their strengths and flaws. And he does have a favorite.

> *We use a German knife more than any other kind. They call it a German eye, an eye-witness, as a matter of fact. It doesn't have a brand name, just a big eye on the blade. We use every other kind. I guess we have fifty or more.*

One of the major secrets to the beauty of Ed Cress's work is the magnificent finish each piece he carves takes on. Any piece from nature is, in itself, beautiful and complete; but when a skilled craftsperson knows how to accentuate that beauty and completeness, it is a marvel for all to behold. So it is with Ed Cress's pieces. Pansy explains how they achieve such a finish on buckeye:

> *We use a sand and seal finish. Just a clear varnish, that's all. The first coat, I rub in all the wood will take and we let that dry a few days. Then we sand it again and give it a light coat. Then, if that's not enough, and the wood takes that up, we give it another coat.*

In explaining the finishing of buckeye, Pansy Cress starts telling how they drain the moisture out of the wood

77

if leaving it upon the hill to season doesn't seem to dry it enough for carving. Her knowledge seems to explain why Ed constantly uses "we" when talking of his creating.

We do also let it dry out while we are working with it; and if we find it drying out too quickly, we put plastic bags over it to hold the moisture in. I say hold the moisture in, but it does dry it from the inside to the outside. We take the bag off and let it dry, and that draws some more out. Then we put it back in. That helps an awful lot.

Now suddenly, as members of their family leave to go to the Swollen Creek bottomland in search of mushrooms, we are aware of the teamwork of Ed and Pansy Cress as they create their mammoth Indians and owls. With his eyes not quite as piercing as they once were, Ed Cress needs the help of the strong woman, the woman who was his pupil during the first year he taught. She is there now, helping him outline if he cannot do it himself.

They admit they are alone in their carving and have found no one whose vision comes close to theirs. They tell us they are the only whittlers they know of in the state who work with the energy they do, create with such intensity.

We see no whittlers that do our kind. Nobody makes the Indians, and nobody that we have found yet does the little animals. They do some of them in a different style. They are more blocked out; and we have found some people that do heads, but we have not found anybody who does the Indians. No one in the state that we know of does it as we do. People tell us we are the best whittlers in the state, but we feel they say it just to make us feel good.

Why would this man, who has worked his entire life in the heaviest industries in his environment while feeding

and loving twelve children beside the Line Creek, continue to dream of the monument in the sycamore, continue to wield an ax, nick himself with the spoke shave, wrestle with a ten-foot piece of buckeye?

> *After you have worked forty or fifty years, you can't just sit down. You have to do something. I couldn't go out and load coal or something like that. I just chop and whittle. I just consider it whittling. In the carving, you just take the wood away from whatever you want to make.*

Ed Cress feels that it is most important for a whittler to pick something he knows to carve — one must know the bone structure to create a beautiful and harmonious piece. He adds that he knows a horse because for years he looked at the tail end of one behind a plow.

Among the woods that Ed Cress whittles and enjoys working with, one finds poplar, walnut, cherry, buckeye, sassafras, sumac, chestnut, catalpa, and mulberry — woods that grow in the Sink Creek Valley and along the Line Creek, all native to Kentucky.

Ed and Pansy Cress let concern show on their faces when they talk of the future of pure whittling and carving. They know they are the last whittlers in the state who travel and show their pieces and the only whittlers who try to make a small living at it. It is, of course, an industry that developed long before the word "industry" was ever spoken, but today is a lost art.

Today Ed's summers are filled with fairs and festivals. He still loads his whittling into a truck and moves about a three-state area, sitting on curbs or on the back of his truck, always drawing a crowd with his Indians, always leaving piles of chips behind him if he stands for long. He lives very close to his wood: therefore, its grain and special markings map his travels on roads most people overlook because of proximity.

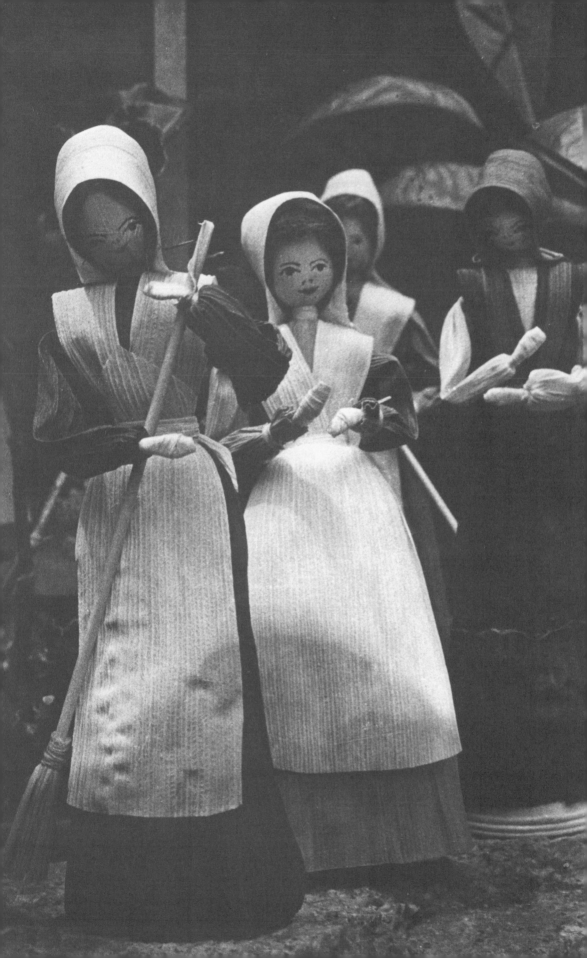

Hands That Still Sing the Great Ballads of Youth
Mallie and Kitty Singleton Ritchie

The Kentucky River is one of the great silent waters of America. As with all things great, it has been charting its own course since the Creation, moving slowly and quietly across the centuries, disturbed by few. Those who have lived upon and near it are nurtured by a force given large bodies of water. Without ever thinking about it, they develop a sense of flow and an understanding that the forces of nature never stop. All may be frozen, but the great river flows out of the sight of the human eye.

If you were to follow the North Fork of the Kentucky from Hazard to Blackey, with the quilt of a summer's lushness draped over the valley, you would realize that you were among some who have never driven a car to their door, for they must pass over the silent river on long suspension bridges to reach their homes. You would also notice a great gentleness among all who follow the river, all who are aware of its presence.

A short way from the confluence of the Elkhorn Branch and the Kentucky River, just out of view of those who pass upon the road that follows the river, live the doll makers, Mallie Ritchie and her sister, Kitty Singleton Ritchie. With their brother Truman, they still live upon

the land their father and mother, Balis and Abigail Hall Ritchie, settled early in this century. It is land rich in the pure heritage of the southern highlands, for no other influence has been greater and truer in the study and application of the pure mountain ballad than that of the Ritchie family. In the world of traditional music, the Ritchie family is legend.

Mallie and Kitty live in a glade. Everything around them is fresh and green, even at the height of a summer's day. The tiny Elkhorn Branch slips past the home and though suffering from the poison of strip-mining, still leads the singing in the glade. In fact, Mallie says now that this latest threat is past, the branch is rapidly regaining its pure voice. There is no one on earth who should know the lyric of the Elkhorn Branch better than Mallie Ritchie, for she has stayed on the family land for over sixty years and listened while members of her family moved from coast to coast across America, taking the lyric of the Elkhorn Branch with them to share.

She is a grand woman. Her face displays the purity and beauty that have surrounded her for a lifetime. Her manner is directed by years of giving, years upon the land where wild flowers abound and the summer months offer a profusion of color and peace. Mallie and Kitty move slowly upon their land, planting and trimming. Together they are two women of quiet grace and inner contentment.

One who sees the magnificent cornhusk dolls they make today, in the same cabin that Katherine Petitt and May Stone visited many, many years ago, soon understands where the simple grace and elegance of the cornhusk sculpture comes from. In the presence of these two women, however, the strengths of the Ritchie heritage are manifest.

No thorough study of the traditional handicrafts of the southern highlands has ever been made without the inclusion of some member of the Ritchie family. Aunt

82

Cord Ritchie may have been the most influential basket maker in the state of Kentucky. Balis Ritchie is responsible for building the musical traditions that Jean and Edna Ritchie have shared with so many for so many years across this nation and the world. Abigail Ritchie was a weaver, mother of thirteen, and taught all who wished to learn how to spin and weave. May, in North Carolina, created the Ritchie doll that Mallie and Kitty have perfected. Today, younger members of the family create with the same purity that has been a Ritchie tradition since Balis led the family in song beside the Elkhorn fifty years ago.

In the cabin Balis Ritchie constructed for his family over sixty years ago, on the land where Abigail was raised, Mallie and Kitty begin to tell of their creating and a bit about the family. It is more like a small museum, with one of Balis Ritchie's favorite dulcimers above the hearth. It houses Mallie's loom, which today Kitty is using. Pictures of the family abound; however, the greatest monuments to the family that can be found in the cabin are Mallie and Kitty themselves.

With hands that never cease working and shaping the cornhusk, and a face that is always amused and pleasant, Kitty tells us very simply and honestly what it is about this glade on the branch that she loves so much:

> It's home. We used to all gather and sing and have good fun. We remodeled this cabin just so the family can come back and gather. We have had as many as sixty-five here. We raised corn up on the hill. Sometimes the whole family would get up and talk until it was time to work, then all go up on the hill and work together all day.

Both ladies tell of the principles their parents lived by and insisted their children adopt: honesty, integrity, the

Mallie & Kitty Singleton Ritchie

83

golden rule. Mallie says her father always stressed the importance of the family as a group. Balis Ritchie knew that if this family would live in harmony among themselves, there would be few heights they could not ascend.

In Kitty's face, one can easily discern the strong qualities of her mother. It is a face that reflects work, work mixed with a constant twinkle in the eye and a half smile upon the lips. Kitty has not lived as long as Mallie on the Ritchie land but has never really been further than across the river and over a few mountains. She explains what may be the major change in the mountains and community in which she and Mallie were raised:

> Well, they have taken away the sense of independence and pride the people used to have. Everything people want, they can get from the government without working today. They don't have too much, but they don't work for what they get— and they complain because they don't get more. I heard one young man say, "If I get more welfare, I'll never work another day in my life." We used to think people who didn't work were low-down. We were always taught that we have to work for what we get. That has been taken away today. This generation just doesn't know how to do anything, like raise their own food if they can't afford to buy it.

When Mallie and Kitty were young girls, they made all their own dolls and toys. They did not use cornhusks: their dolls were of rag and paper. Their sister May created the first Ritchie doll. She saw her first cornhusk dolls at the Hindman Settlement School many years ago. She provided

the impetus for Mallie and the rest of the doll makers in the family. May still makes dolls in North Carolina.

When Mallie was much younger, she would weave upon the loom that sits in the room where she and Kitty make dolls. Abigail Ritchie and Berea College taught young Mallie the use of the loom and the importance of weaving. Abigail also taught all her daughters how to quilt, and their eyes come alive when talking of the beauty of the quilting their mother did.

Kitty feels the most important aspect of making their dolls is remembering to make them very firmly. All too often, people who try to make the Ritchie doll make them too loosely and they unravel. She says you must mold the body in your hands and not be afraid to be firm.

The materials necessary for fashioning a Ritchie doll are quite simple and easy to procure. Before their dolls gained such national and international attention, the sisters created them from the corn their brother raised expressly for them on the family land. In addition to the husk, they use part of the warp from their loom called the throng, raffia, Rit dye, a very light wire to wrap for the arms, and a little corn silk and hemp rope for hair. Mallie draws the delicate facial expressions. In the hands of the two sisters, these simple materials become small monuments to the delicacy of life. And even as they speak, the ladies are continually transforming the moist cornhusk into elegance.

Thinking back on the musical influence on and of the family, Kitty recounts briefly their first encounter with a dulcimer:

I don't remember hearing anyone else play except father. Uncle Will Singleton lived up here at Viper,

though. He was my mother's uncle. He made the box kind of dulcimer. He was interested in all the old things. He used to make piggins, a small wooden pail out of bark. He made me a dulcimer one time. He's about the oldest dulcimer maker around here, except for Thomas.

Of course, when we went to the Pine Mountain Settlement School, they played up song and dulcimer very much. Edna was presented a dulcimer there for knowing the most songs and the most ballads. Jean was little and we would come home and sing them and we would learn them, and then when we would come back from Pine Mountain, several of us, we would meet on the front porch at night. We used to have a porch running all the way around the back. We would all sit on the porch and sing and teach the songs we learned at Pine Mountain. I was at Pine Mountain when Cecil Sharp came, and he taught us a lot and gathered a lot of our songs. Dad learned to play on the Thomas dulcimer Edna won at Pine Mountain.

Perhaps reminded by the aged dulcimer that once belonged to Balis Ritchie, both ladies recall his desire to make the place in which he was a better one for his family and mankind:

He printed the first paper in Knott County, the Knott County News Record. We lived at Hindman for two or three years, and he printed the paper and May set type for him. Had to do it all by hand. As I said, he and mother started the first post office in Knott County also.

Mallie Ritchie carries within her soul this same desire. She has quietly watched her family move in and out of her glade for so many years, always preparing a bed for their return. She has never removed herself very far from the walls that first reverberated with the voice of those Thomas and Singleton dulcimers. She has lived with the visions of grace and elegance her parents taught years ago and has captured them in the cornhusk she sculpts. Many others in the family are now creating the Ritchie doll, but there can be no question that Mallie and Kitty's are as graceful as the lyric of the Elkhorn Branch.

Mallie & Kitty Singleton Ritchie

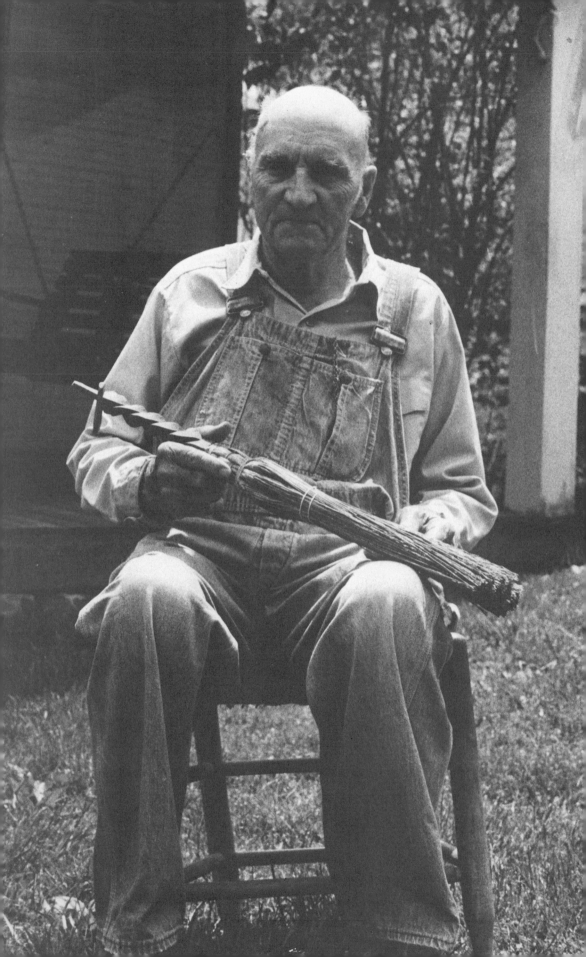

Listening for the Reply
Gilbert Lewis

The mountains of America have perpetuated a breed of men that exists nowhere else on earth, men who have learned to live harmoniously in their immediate environment, although ofttimes cruel and punishing. Not men of great academic credential, they are persons who have learned at the height of their environment's fury and ecstacy the importance of reason.

There are but a few of these men left in the mountains of America. Most have passed on or have followed their children and the gentle creeks that flow from the soul of their mountains to the country beyond. One who was upon the mountain as John Fox wrote of the Lonesome Pine, one who was in the field as the great William Creech asked his God for guidance in educating those of his valley, one who has not left is Gilbert Lewis.

At the foot of the mountain, Isaacs' Creek flows. Just a little below the road and a short distance from the foot of that mountain live Gilbert and Arwilla Lewis. Theirs is a cabin often the focal point of activity on Issacs' Creek because of the abundance of its inhabitants. They are much stiller now than in years past. Neither Gilbert nor Arwilla Lewis go upon the land as often as they once did. Gilbert Lewis raises his own broom corn, corn he uses to make what are perhaps the finest brooms in America — certainly, the most pleasing to the eye. They raise their garden in the same spot they have for years and sup on its bounty. If hickory bark is to be found, Gilbert Lewis

weaves a chair seat. He is the most respected chair bottomer in his valley. He was born among the hickory and has worked it. He knows its nature as well as any living man. Today his hands eagerly await more hickory, but it is slow in coming and hard to find.

In their cabin just below the road, Gilbert and Arwilla sit before a fireplace made of thirteen different woods, all finished and sanded to accentuate their beauty. It is an impressive sight, these two grandchildren of the valley. Gilbert Lewis speaks very deliberately when telling of his birth date and place.

He was born at the mouth of Elliot's Branch just a little below Big Laurel late in 1891 and has never left the mountains. He has worked the same fields in primarily the same fashion since he was old enough to work. His early life differed little from that of his ancestors—work from the sun's ascent to its departure with very little play as a child.

Gilbert Lewis was a determined young man. His only recreation was his farm, and he learned to dream the dreams of practical men. Distant sounds did not drive him, and he found little time alone with the fantasies of youth; but he did learn the satisfaction of doing things correctly and derived great pleasure in seeing things endure. When Gilbert Lewis does anything, it will endure or it would not have been done. His face quite simply tells all who see it that his life has been well worth living.

Gilbert Lewis is never alone. His wife and vision, Arwilla, is near him constantly. She is the granddaughter of Uncle William and Aunt Sal (Sal Dixon) Creech, who kindled in the valley of the Greasy and the Laurel the first sense of community and of the need for educational growth among these children of the pioneers. The gentle Lewises who face you are the product of the community the Creeches created.

Though not a broom maker all his life, Gilbert Lewis creates the purest and most aesthetically pleasing of brooms. He makes perhaps thirty brooms a year, and most go to his

community. Only a few find their way to either coast. They are cherished in the surrounding community, Issacs' Creek. The brooms are made of only the hardiest broom corn strains—rich purple, gold, orange, tan, and black—and have handles of the finest natural black walnut. They have been known to last for years with constant use.

Gilbert Lewis is a bit concerned because he has no broom corn now and hasn't put his seed in the ground yet. He has a few walnut handles whittled, but it will be months before another broom is made. He has sent word throughout the community that he needs the corn but knows that in the end it will be up to him to supply himself.

Today there is concern in the valley. The people of Issacs' Creek burn much coal, and a broom is an essential tool of life. When Gilbert Lewis retires from making brooms, there is apparently no one ready to learn from him and continue that tradition. He waits for some person to desire actively to learn his method. The children of the valley move along the road that runs just above the cabin on Issacs' Creek, and many stop to sit on the porch and visit, but soon they move off and down the road, many to become the eternal loiterers who dot the mountains of Gilbert Lewis's community. He still waits. He could shame a son or grandson into perpetuating the Lewis Broom, but too much would be lost. The brooms have too much character and personality to ever be reproduced without total accord.

Gilbert Lewis is the voice of his valley. Today, though his voice trembles ever so slightly when he speaks, he speaks and those who listen, listen. In a valley that is all lyric, his may ring the truest. Stories of his portrayal of Simon in the valley's nativity play still stir all who witnessed Gilbert Lewis move slowly before the audience, lift his eyes unto Heaven, and in a voice few have ever heard in their human experience, talk to his God so that all present are still listening for the reply.

Gilbert Lewis

91

All That They are Asking for is Love
Martha Nelson and her Boys

Louisville, Kentucky, in the shawl of the latter months of winter is, indeed, the image of Mother Introspection. The greyness follows one everywhere, causing all to stand and look inward for longer periods of time than in autumn. The great mass of naked arms reaching to the heavens, void of all foliage, casts skeleton shadows of life. Most do look inward in Louisville in the latter months of winter.

Had you been draped in the shawl of such a day a short time ago and had you been walking the streets looking very intently at the earth below, you might have chanced to meet Daniel, one of Martha Nelson's children. Perhaps, at first, a little out of your vision but most certainly not out of your sight.

Martha Nelson is a teacher of art. She is an artist who paints, quilts, and does textile sculpture. She prefers to be called a doll maker.

Martha Nelson is one who would rather listen than talk. She is one who would rather look than listen, rather touch than look. The only time she does like to talk is with her friends, and she does like to talk an awful lot about her dolls. Otherwise, except for her hands as she works, and as she teaches art in Hazard, Kentucky, she is very still and quiet.

93

Martha Nelson was born in Mayfield, a small town in western Kentucky, not too far from the Mississippi River. Mayfield is rich farmland, fertile until the ground freezes. It is a very comfortable town and a town that allows most to grow at their own pace. One is never pushed too hard in Mayfield, Kentucky. Like so much of Kentucky, it allows you to look at the trees a bit more as you move upon its streets and lanes. Ofttimes, those who pass you, though complete strangers, wave.

Martha Nelson's family is large. When she was young, she had little time alone, for she was always with a brother or a sister. Martha's is a family with strong emphasis on caring, and caring is unquestionably one of the major themes of her creating. Her family was well founded on togetherness and love, and her creative energies further those themes above all others.

When she was young, Martha's hands were rarely still. Playing dolls with her sisters often consisted of making clothes for their dolls and making dolls for their clothes. Clothes are a very important part of her dolls and are never chosen lightly.

Having a mother who actively involved her children in whatever she was doing was an important part of Martha's upbringing. If her mother was baking a pie and the girls came to the kitchen with curiosity, they would be involved in the process. Or the process would be put aside while she worked out a problem her children had.

Outside Martha's family, the first major influence on her doll creating were two stocking dolls she saw at the library. They were constructed of cotton stockings and were a very old man and woman.

When I got excited about stocking dolls, it was because of a toy show down at the library. There

94

was an old couple, a man and his wife. They were made out of stockings, like cotton stockings. I was really taken away with them; and when I saw what they were made of, I went home and made a doll. That's the way it turned out. Because I was interested in babies, I couldn't make an old couple, but I now go back and forth between old people and babies because they are so related. There is that simple purity.

Martha tries to make her dolls as simple as possible so that love and time will act upon them and age them naturally. She will tell you that it is easy to add character to the babies she has created, but to make them simple so that they have a whole life to look forward to without the fetters of too much character is the most difficult task in her creating. Sometimes dolls she creates old become babies:

A couple have started out as old men and end up as babies. It's like they are in baby form, but I can see grownups in them. Like Daniel. He reminds me of someone named Daniel. Daniel doesn't look exactly like that, but he has the same gentleness. They don't hate anybody and are not mean to anybody.

No one taught her to use the nylon her babies are made of. After seeing those first two sculptures in the library in Louisville, she searched out the proper materials. Nylon stockings, perhaps because of their lifelike feel, have proven the most successful. No one has shown her how to stitch the mouths that can both laugh and cry in a single day. Martha taught herself how to sew the toes that so many have squeezed and wiggled as they did those of their own children.

95

Martha Nelson has been creating her soft, sculptured babies for three years and does not know how many she has made. She will tell you that aside from herself, her sister Ann has certainly been the individual most responsible for the continued evolvement of the babies. The sisters have been creating together since birth, and it is Ann who let Martha put the first baby doll she ever created in a show Martha was having. To the dismay of both ladies, it sold so Martha had to make another to replace it.

This lady from Mayfield, Kentucky, who has been sewing for as long as she can remember and most likely this instant has a needle in her hand, maintains that her ability to create with textiles and needle is based more on feeling and touching than on skill:

> *The kids can do them. The dolls. It just takes a lot of touching. You really have to feel. You can make the material do whatever you want if you will just really touch it. Just pull the material out and sew around it.*

Martha Nelson is really rather pleased at the response her babies have received in the hills of eastern Kentucky. Being from the western portion of the state with its mellowness and gentle beauty, she wasn't at all certain how she would be received in a mining town such as Hazard. She wasn't at all certain how her dolls would be received.

There is no question in Martha's mind that she will create dolls for the rest of her life, though they will not be for sale forever. She knows the babies she creates today will eventually evolve into a little different form, but Martha does not ponder the future, for she is a very present

person. She still lives in and with every baby she creates. Some leave her much sooner than she wants.

Martha Nelson

One of the true beauties of Martha Nelson's teaching in Hazard is the perspective she offers. Being a creator of life, with emphasis on the pure and young, she is able to watch her students create on their level.

Martha Nelson plans to be a child all her life, loves it, and has no intentions of ever growing up all the way. She recalls being a child and how children relive their new and exciting experiences for long periods of time. If they go to the fair, they play fair. If they are moved by a cowboy movie, they become cowboys for weeks on end. Martha has captured that essence with her teaching; and so, after a potter comes to her class and involves her students in their hands and themselves, Martha Nelson finds many little hands playing potter long after the lessons have ended. She feels this is so important in teaching, yet it is only successful when accompanied by love for whatever the activity includes.

The city of Louisville may be the place she loves most. The guidance and harmony she found while growing at the Louisville School of Art and the persons who helped her grow have all become part of her. But she loves her town of Mayfield and the strong sense of family that exists for her there. Teaching in Hazard has finally brought her close to children, allowed her to be, at once, a woman, a child, and a creator of children.

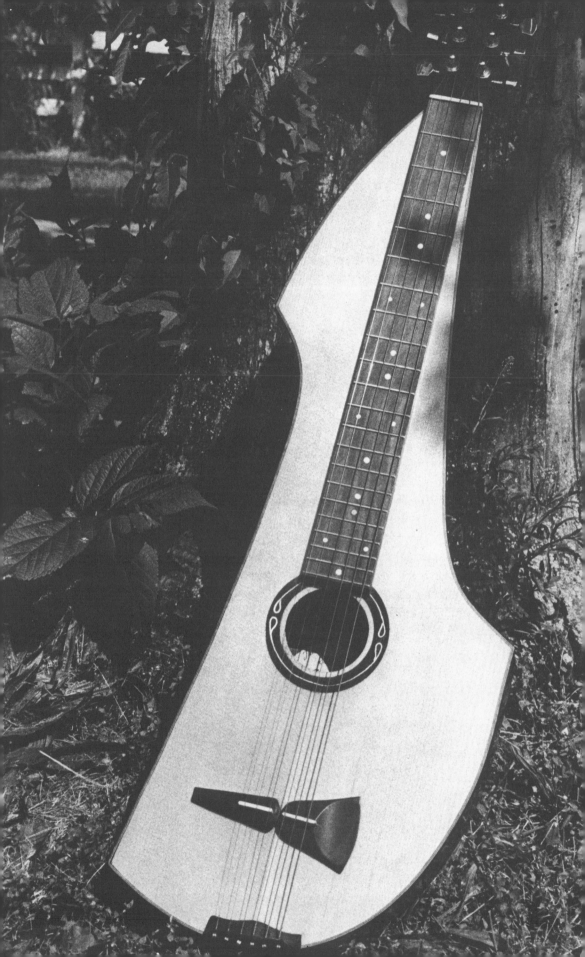

Tempted from Deep Within the Zebra Wood
Thomas Thiel

The path that takes one from the Conception's Studio, nestled within the blue of central Kentucky's grass, to Happy Top, which looks the great mountains of east Kentucky squarely in the eye, is currently being paved with the genius of Thomas A. Thiel, artificer.

The Conception's Studio is located on a small farm within the realm of the blue grass, just a little northwest of Lexington. The studio is surrounded by rural, but not vernal, environs. Once inside the studio, however, little outside matters, for the creative energies and vision that come from within are building a society predicated on harmony, not merely a faceless society, the muse of those well trained in mental gymnastics, a society in which the first log has been hewn and the harmony of the winds has been caressed. Happy Top will soon be the home of Thomas A. Thiel, his family, their family of fellow artificers. If one travels at at least the altitude of Happy Top for a period of time, rarely descending, then very slowly seeks out the great white shape of the Conception's Studio, one may, perchance, find Thomas Thiel within. Thomas Thiel creates beautiful dulcimers in an environment famous for them.

You see, I don't make things. I'm a poet, not really a craftsman. I write things about my soul. I write music. I write songs, because people buy material.

For the past several years, the material Thomas Thiel has been letting people buy has been harmony, harmony one lets nature conceive and harmony you must caress and tempt from deep within the rosewood and zebra wood.

I make music. I write music. A musical instrument is a logical expression of that . . . it's really beautiful, intricate. Say, for instance, this Aeolian harp, this Greek instrument, Aeolus is the Greek God of the wind. The Aeolian harp is his song. I made it, not because anyone would buy it, but because it is beautiful. It does beautiful things.

Beautiful things are really what Conception's artificer is all about. His life has been a quest for beauty and form, to which he has brought refined technological skill and development, love and concern for the materials with which he creates, and poetic vision. That is all. Put those components together, and you have a Thomas Thiel dulcimer or guitar or Aeolian harp or

Most of the things I like to do are first-time things Like this erotic guitar. The guitar, for me, is a sensual symbol. I symbolize that, in this guitar, is a nude female curled up and abstracted, carved out of one solid hunk of rosewood. To be an electrical guitar . . . rosewood is considered the prime wood for musical instruments. I make that once, rosewood and twenty-four carat gold.

Thomas Thiel plans to create soon a dulcimer in true female form, another example of his technical vision, the interfusion of body and soul working toward perfect harmony.

Thomas Thiel

Thomas Thiel was born in northern Kentucky and spent most of his youth in the nature that fringed a great urban area. He did spend much time in the forest when young and admits to being stimulated by the forest today. It is to the forest that Thomas Thiel travels to collect his thoughts when pressures or creating wax too heavy upon him.

His introduction to studies of the spirit and soul came about while he was a brother in a religious order based on social action and education and a student at the University of Dayton. While studying, his days were filled with reflection and meditation. Thomas Thiel studied the development of the human spirit and became involved in helping others learn to live and develop at their own pace.

He left the religious order when he found it easier to apply its teachings outside its structure. You see, this man has always been interested in helping the child, whether four or fifty-eight, to develop, "to come to flower." Today, he does much personal consultation and continues research into the philosophy of education, in which he holds a degree from the University of Kentucky. With his wife, Kathy, he has been involved in starting and developing several free-format schools.

The seed planted long ago, deep within Thomas Thiel's forest, which has been growing toward helping others achieve a true sense of self, has matured into an environment that itself is growing every day.

We have this land down at Happy Top. We have architected and designed our first building, which

101

eventually will be photographic studios, workshops—metal workshop, sculpture workshop—a creative environment on top of a cliff, all glass. A view for eleven miles. We have other buildings designed. One is a hyperbolic function, sound and music listening room, four horns coming from each side. Each horn is a hyperbola, the wings of a building, the function of which is to expand sounds. We are going to make this place a center where people can come and grow. The creative process is compatible with the whole idea of Happy Top, making an instrument, a sculpture. Most people are embarassed to create anything they have been taught to not be.

Happy Top will afford those willing to sojourn an opportunity to develop total harmony. That is one of the major themes of Thomas Thiel's reality.

Thomas Thiel is an artificer who believes in using technology, one who believes in mastering his tools.

I use technology as much as I can. All technology is a tool for man to develop. I have an idea that a lot of people who are from a primitive environment, or are going back to the earth, want to do things the old way, with draw knife and chisel. The pure way. I am just after personal dialogue with the material, and the means mean little to me as long as the technology is never too fast for one to keep up with.

The first object Thomas Thiel ever created was a dulcimer. It was made for a friend in Lexington, Kentucky; at the time he had no idea what a dulcimer was. That was the start of his creating, other than poetry and music. For the past several years, he has made roughly

twenty dulcimers a year, usually created in the early spring for the fairs and festivals of the summer, those fairs throughout the country where the purest dialogue and statements of man's harmony with his present are displayed and shared upon the earth.

Thomas Thiel

Currently, Thomas Thiel enjoys making guitars more than dulcimers. He finds them much more complex. He feels that the dulcimer, when developed to its fullest harmonic potentials, becomes a guitar in voice.

In describing the process of creating his sculptured rosewood guitar, Thomas Thiel does indeed take you beyond the world of the draw knife:

> *I have a model and will do some photo sessions with her. I'm probably going to do the guitar in clay first, then fire it, then cast it in brass or bronze, materials that are actually more easily worked than wood. Especially this giant piece of rosewood. I have this power for sensual image that I carry in my head; however, if I start working on this giant piece of wood, it may end up just sawdust, so I will explore first in other materials.*

Little in the creating and life of Thomas Thiel is arrived at irrationally.

In developing his dulcimers, the only guidance he has sought was that of the master dulcimer maker, Homer Ledford, far and away the most renowned dulcimer maker in the state of Kentucky.

> *I don't just make dulcimers. I taper the wood down thin on the edges. If you look at the cross sections of my wood, you see it looks like a lens. The wood is supported by the sides of the instrument. So if it is*

resonating, it will resonate less out by the side. If you thin it down correspondingly, which lets it resonate more, what you are doing is compensating for that which is rigid and get more surface area vibrating.

Thomas Thiel selected the environment for Happy Top after an intense search and much careful thought, research, work, and vision.

We found the biggest plot of land we could between major civilizations. We started looking for land on the Tennessee border and came north. Our criteria were: no coal mining, very little prospect of industrialization. In a forest—it had to be scheduled, friendly topography—we found a bit of land. It rolls, has a bit of a hollow with stream, has a bench overlooking a ridge with a nice view, hills, cave, hand-drilled well.

The earth where Happy Top rests has already felt the Thiels' caress. The concrete block for the first structure has been laid, the foundation for a massive building that will be two and one-half stories high and have no parallel walls. All electricity is to be generated by the wind, and heat will come from a heat pump.

You take heat out of a body of water. We built a lake last winter. There is heat in that water, normally fifty degrees worth, forty at the least in winter. Earth heats up the water, that is, even with the earth frozen above. And forty degrees above absolute zero is a lot of heat. You can raise the temperature of that water with a heat pump, something like a refrigerator. You compress freon and make it hot, expand it, and make it cold. You can put your heat

pump inside your house, and circulate warm water through the rooms. You get about eighty percent of your heat for free that way.

Thomas
Thiel

Because so much of Happy Top is visually oriented, there is to be glass wherever possible. To prevent great heat loss through the glass, Thomas Thiel has developed a window that will insulate against the chill eleven-mile-an-hour winds that constantly pass over the mountain top.

Thomas Thiel readily admits that one of the prime motivators behind his building Happy Top is the senseless destruction in search of energy sources. He feels that harnessing a little wind, which is allowed to live forever, makes more sense than destroying myriads of trees a year for power lines or thousands of acres of forest a year in search of coal. In his own words, he is attempting to create a "self-sustaining rural environment" with animosity toward no living thing. The foundation has certainly been laid.

The philosophies and technologies behind each Thiel creation run a remarkable gamut from one's active religious and metaphysical rationalizations and their application to scientific discovery. The resulting creation emerges at the point that best serves mankind, making for a very pure and true product.

Thomas Thiel is another of the great Kentucky artificers who presently live upon its earth in harmony with all about them, a man who is directed by the present a little more than most and allows the present to dictate much of his activity and creating; however, much active search and research has gone into his ability to capture as much of the present as possible. His has not been a passive search, but has taken him far from Kentucky, then returned him, returned him to the state in which he was raised to draw from its great energies without destroying them.

105

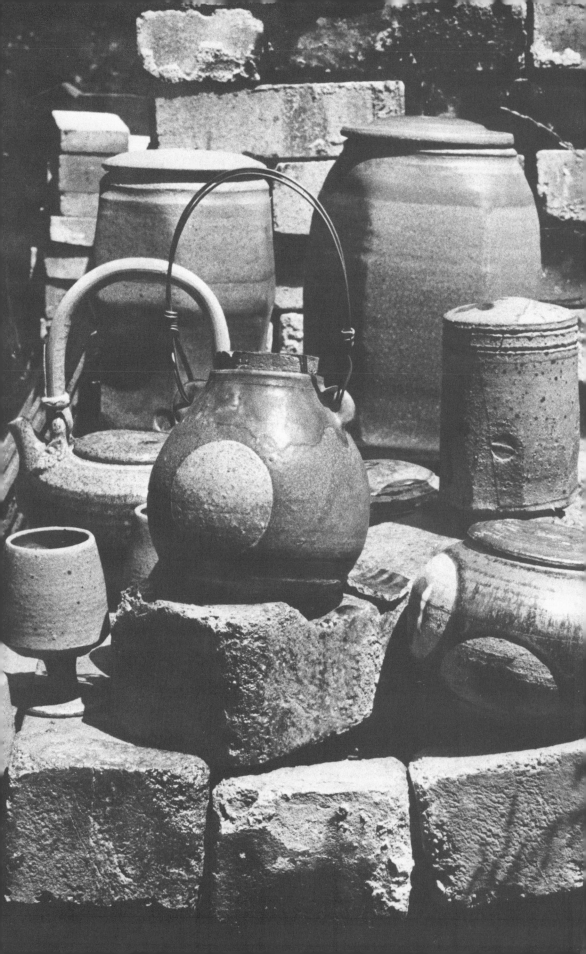

Upon Clear Waters That Feed the Silent River
Marshall Thompson

Just north of Frankfort is where the silent Kentucky River is perhaps the stillest, especially when the weight of a summer's day presses heavy upon its surface, forcing all life as far below as possible. This great, silent river's life-giving force is omnipresent. Nowhere along its banks can one not find plants. When the heavy vapors of summer embrace the land round about the river, few are diminished, most grow abundantly.

Not too distant from those waters of the Kentucky, in fact, upon clear waters that help feed the silent river, is a glade where Kentucky potter Marshall Thompson makes his home. Called by some the Rising Moon Potter, Marshall Thompson makes pots that may very well be found along the banks of that clear creek five thousand years from now.

For several years Marshall Thompson has been making pots for mankind. He is another of the great artists of handicraft. Although driven by poetic vision and application and dwelling within an environment ofttimes divorced from the flow and ebb of current American mass thrust, he remains true to the poetic beauty of utility. Within his glade he has begun to build a monument to mankind's strivings to harness creative energies for the betterment of

society, regardless of glade. He is always driven by active technological enrichment, education, great creative and poetic vision and energies. For one so deep within nature's stillness, the Rising Moon Potter's energies are boundless.

Rarely does Marshall Thompson leave the creek upon which his family lives and he creates. True dialogue with those who live perpetually with their work really comes about once a year. In May, he and Ruth and their son Clay leave the land and travel to the summer fair of the Guild of Kentucky Artists and Craftsmen at Berea, Kentucky, for three days.

Once a year I get to see the people who buy my pots. It's just like going to school. It's like having a teacher descend on you. You get to watch fifteen thousand people pick up your stuff, see how they pick it up and see what they look at. It's nice. It's nice to talk to people and tell them why you sit at home and do that. How it works, why it's working like that, and what you were thinking to get it there. I get a new set of standards at Berea. I don't do production ware, but I do get to see what is there, too. When I tell someone what my pots are about.

Marshall Thompson gains from those associations enough direction for a year's creating, and then he must quicken his pace too much, as it is, in order to be prepared for the next fair.

The structures he has built and rebuilt to house his family and studio and kiln are all constructed of materials that have lived before and that he, Ruth, and a few friends have invested part of their lives to make live once again. The brick for his kiln came from a giant distillery that they had had to tear down and reassemble:

The kiln here started out being wood fired. We fired two chambers. The first was the stoneware; the second, bisque. I am not a woodcutter. The kiln was one hundred and fifty cubic feet, and that's a lot of space to fire. It took seven and one-half cords of cedar sapling wood from the sawmill up the hill and thirteen and one-half hours to fire it.

Marshall Thompson

Today that kiln has been cut to a single chamber and is fired by oil. It is a downdraft kiln with no bag walls as most kilns. He shoots into long troughs along the side of the kiln, which breaks the flame up enough so that there is little flashing, all for a pot or mug that you can wash and he can live with.

The other structures in their glade all come from the same minds. The shop or studio is a twenty-five-foot tower with eighteen sliding shoji screens that open onto creek and limb. The song of the tree frog is rarely far from the ear of Marshall Thompson.

His studio has thirteen hundred feet of floor space with redwood siding. Again the mass of materials came from environments in which they had already been seasoned. The redwood came from a thirty- by thirty- by forty-foot water tower the Thompsons took down with claw hammer and nail puller.

Today, he is pleased with the sense of community he sees developing within a small segment of the human population drawn to environments that are warm, quiet, gentle, and touching. Within his small community, this potter is a happy person. He most certainly understands that, upon the road, he could conceivably find a more plastic comfort and, if he did not worry about each mug he produces lasting twenty years, he would, perhaps, realize more monetary gain. Marshall Thompson believes

man is but a seventy-year box of energy that can be spent in any fashion he chooses. Living in his glade with his family, creating that which is useful and truly helps mankind, regardless of how many boilers must be torn down, brick by brick, is the most comfort he has experienced in his life.

The Rising Moon Potter uses clays from Florida, Georgia, North Carolina, South Carolina, Virginia, Tennessee, Ohio, Kentucky, and Wyoming. These are the clays that Marshall Thompson feels like putting the most of himself into. He likes to grow aluminosilicate crystals.

> *What that does is form a crystal in the lattice work of the clay that holds the thing together like a sponge. You have a sponge structure holding the body together. You have a heating element and bulk. You put tea in and it stays hot for a long time. I like to work a real coarse clay. The aluminosilicate crystals and the coarseness of the clay make it durable. I test it. When I get a cup out of the kiln, I put it on the stove, get it real hot, and pour cold water over it and see what it does to the piece. That's a simple test and seems to work.*

To him firing is like going before a jury. He is either right or wrong; he has or has not done it. He admits one can dress up that which walks from the fire a little, and most potters do. Marshall Thompson does grind the feet of his pots down so that he can place them on a table.

A potter who strives to create that closest to the needs of man with as little dressing as possible, Marshall Thompson equates utility and purity with true beauty:

> *I don't like to be very abstract in what I do. I don't like to be conceptual too much. I like an*

110

immediate relationship with what you see visually and what you know in nature, what you're around. I can't see any other human thing except what I am. I make pots for people to use. I have got to direct a good deal of my energy towards someone else because someone else is going to use this pot.

Marshall Thompson

Looking to the future, Rising Moon Pottery plans to close down its use of fossil fuels because they cannot replenish them. They have become necessities for man to survive. If the time comes that clay pots are not to be used because there is something else that does the job better, Marshall Thompson will cease making pots.

I have thought about going now to China and seeing what people who are living in tight situations are doing. They are feeding themselves, are providing pots for themselves. They are not doing much exporting. They are not tapping the rest of the world. Their communities are living with themselves. I think if I learn a lot from them, then I can help us prosper, us being me and my neighbors in California and New York.

A Little North of Dizney and South of Kingdom Come
Pine Mountain Settlement School

t is still there, a little north of Dizney and south of Kingdom Come, an aboretum that has, for over seventy years, nurtured the flora and humanity of those who have touched it or have caught its fragrance on the wind.

Nestled on the north side of the Pine Mountain stands the Settlement School with the same name. Today, it functions as a living monument to the purity, charity, unbreakable will, and spirit of those who learned to live in harmony with their eastern Kentucky hills, those who have learned to repay the earth and their God for the gifts that each has bestowed. It is an institution that today teaches the great lessons of existence by teaching and giving a child the opportunity to listen to the subtle murmurings of nature and of life.

The school was conceived in the mind of Uncle William Creech, Sr., long before 1913 when he gave the land upon which it stands today. William Creech, Sr., was born late in October of 1845 on the Poor Fork of the Cumberland River. Today, this area is known as Cumberland, Kentucky. His parents were deeply religious and extremely poor.

I think they were true Christians and are gone to rest in Jesus our Lord. Will say that I never heard one of them ever swear an oath or use any profane language, and was always strictly in obedience to the law of the country and God and tried to raise their children in obedience to their Savior, but being very poor was not able to give their children but little schooling, so I got enough to read and write a little when the Civil War broke out in 1861.

After serving a short time in the Union Army, William Creech returned to Cumberland and married Sally Dixon in March of 1866. After several futile years of attempting to farm on the Poor Fork, he moved his young family across the mountains to some "wild land on the head of Greasy." The first several years on the Greasy were filled with little but the desire to survive in the wilderness. Work never stopped, day or night.

Even while hewing the massive pines and confronting the elements with little technology and much use of back and hands, he dreamed of a school for his sons and daughters and their contemporaries. It was his desire that the children of the valley of the Laurel and the Greasy be afforded the opportunity for an education. Yet there was little time for him to pursue the education he desired because his day's work never ended.

Clearing land was the greatest industry for the fall and winter for several years until we had enough for what we needed for wheat, corn, rye, flax, and buckwheat. In the dry season of the year we had to grind out meal on a hand mill, which was very hard work. By raising the flax and sheep, my wife carded

and spun and wove cloth to make clothes for us all while I tanned leather and made all the shoes that we wore. While the days was warm and dry, we plowed and hoed corn; and wet days and by night, I worked in my blacksmith shop and my wife knit and spun. But when the children got large enough to work, the boys helped me and the girls helped their mother. But all worked together in the cornfield.

Years passed and Sally Dixon Creech still spun and carded while William Creech worked his land and leather. Yet, forty years after they moved to the head of Greasy, there still was no school. With grandchildren taking the place of his children in and around the cabin, Uncle William was indeed sad. He saw little opportunity for his grandchildren to become educated and was almost certain the educational fate of their fathers was to befall them. Then what had been William Creech, Sr's. vision for over forty years became reality.

About the first of May in the year 1911, the Rev. Lewis Lyttle stopped with me for dinner and read a letter to me and said two women at Hindman, Kentucky, wanted to start a new school near the Pine Mountain. And I at once offered to do anything that I could to help and I was visited by Miss Katherine Petitt and Miss Butler and later by Miss Petitt and Miss Ethel de Long who wanted to take up the work to build a new school.

William Creech, Sr., offered Katherine Petitt of Lexington, Kentucky, co-founder of the Hindman Settlement School in Knott County, along with Miss May Stone in 1903, the land to build the school at the Pine Mountain

if the minor technical difficulties could be worked out. The problems were resolved, and these women and co-founder Ethel de Long Zande, who came after teaching English in Springfield, Massachusetts, to the hills of eastern Kentucky, founded the school on two hundred and fifty acres deeded them by Uncle William Creech.

Perhaps, the best description of the pioneer educator and humanitarian Katherine Petitt can be found in the *Pine Mountain Album* printed in 1963, which traces the first fifty years of the school's heritage.

Who is this anyway, standing with her back to us? It could be Miss Petitt. You seldom find a picture of her either sitting or facing you, but now and then you come across the back view of a stalwart figure seeing that something which needs doing is being done.

What is she pointing at? There are many things it could be. In 1913 Miss de Long wrote, "I wish you could see Miss Petitt making the children clean up the yard. A piece of string 3 inches long does not escape her, and an eggshell she can see at a distance of 50 yards." We may think, "what does it matter?" but now in 1963 when counties in east Kentucky are vigorously supporting "clean up" campaigns we realize her wisdom of fifty years ago in setting a standard for cleanliness, order and beauty as one of the foundations on which the school was to stand.

Perhaps it is not a distant "eggshell" she is pointing at. Perhaps she has seen someone toting a gun on the school grounds. She always crusaded against careless shooting and drunkeness, tried to find other ways for people to enjoy themselves, and encouraged everything which led to better citizenship. She was appalled to find men selling their votes for dollars or whiskey.

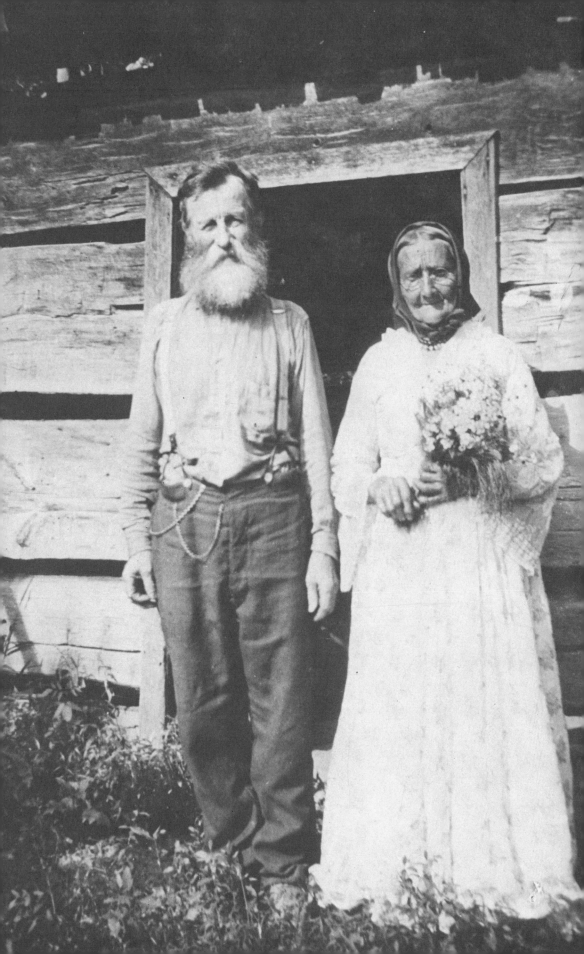

Or perhaps she is directing the draining of the bottom land, or showing where a fence should be set to keep wandering hogs from the school garden. She learned from Uncle William how to raise flax, from Mr. Descham how to care for a forest. She experimented with raising indigo for the dyepot. The list is endless, for there was nothing which affected the life of people in this area which she did not make her concern, especially the human resources—the children in whom she saw and from whom she demanded the best that was in them.

The same publication describes Ethel de Long Zande:

This is Mrs. Zande and her dulcimer, and a group of children around her. How many gifts she brought, especially the gift of enjoyment of what was beautiful, and the capacity to enter into the lives of others with understanding and affection.

In 1917 the great folklorist, Cecil Sharp, was delighted with this treasure, and dedicated a book on the running set to Pine Mountain. In 1923 the school published its first book of ballads. Miss Wells collected songs from singing Willie Nolan, Fiddler John, and Abner Boggs; later she wrote a book on ballads. Some of the Ritchies contributed from their store of ballads to the school treasury.

Nor do we forget Richard Chase, who wrote "The Jack Tales," received his first experiences of the magic of Appalachian folklore at Pine Mountain in the 1920's, and Leonard Roberts who collected many tales, was a teacher in this school.

They are still there, the ghosts, spirits, reflections, manifestations, and alter egos of those great humanitarians and teachers. Just a little north of Dizney and south of Kingdom Come in the valley of the Laurel and the Greasy, a true family of man headed by the love and intellect of two great families touches all life.

In America in 1976, Mary and Burton Rogers and the Reverend Alvin Boggs and family direct the Pine Mountain Settlement School. Along with a staff chosen for very spiritual and humanitarian reasons, they daily teach all who wish to study what is right with life and how to view existence.

We' uns that can't read or write have got a heap of time to think, and that's why we know more than you all.

Sally Dixon Creech

Pine Mountain School

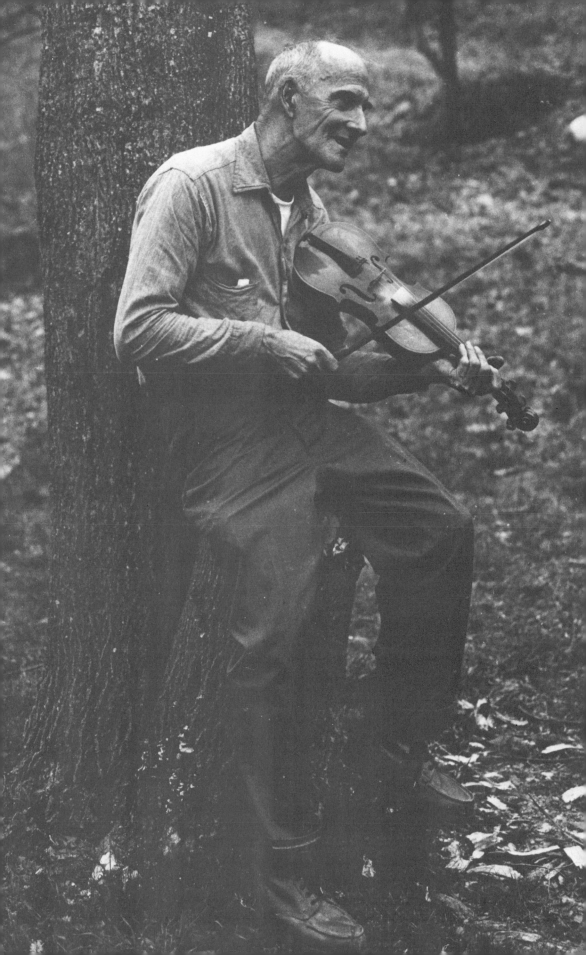

Epilogue

*It is not down in any map; true places
never are.*

Herman Melville

How many miles have we sojourned since first
discovering there is a "little bit" above Kingdom
Come? At dusk the soulful voice of Oaksie's
fiddle can often be discerned lamenting the great mining
tragedy that recently has left a myriad of Letcher County
boys eternally entombed within the soul of their earth. We
have seen that tragedy in the eyes of Delta and Belva Hall
as they recounted days within the year past when a slight
brown haze ascended their mountain. The Reverend Alvin
Boggs is, today, upon his mountain administering and
catching all up with his ceaseless energy and love. As we
moved upon those same mountains, we have touched their
pulse and their remarkable environments and art.

The miles roll on and on as one travels the roads,
paths, and hollows. Hazard, Viper, Blackey, Whitesburg,
Big Cowan, Kingdom Come, Gilley, Gordon, Jacob's
Creek, Richmond, Berea, Issacs' Creek, Pine Mountain,
Greenup, Big Laurel, Little Laurel, Stoney Fork, Cutshin,
Gatlinburg, Hyden, Beverly, Pineville, Barbourville, Ash-
ville, Brasstown, Harlan, Cumberland, Jenkins, Pikeville,
Hindman, Lexington, Clays Ferry, Knoxville, Pippa
Passas, Stinking Creek, and Nonesuch—names that do not

Epilogue begin to scratch the surface of those associated with the history of unfettered Kentucky, Appalachian, and southern highland art and handicraft. Yet these are the names that bring a glimmer of acknowledgment from the learned traveler to "these cliffs so wild and horrid."

Presently, it is still not difficult to be overwhelmed by the topography and the humanity who create their art within the Appalachian quadrangle of the southern highlands and lush valleys and meadows of Central Kentucky. As one passes GET RIGHT WITH GOD and JESUS IS THE WAY signs and traces of faint trails that lie alongside the thin two-lane roads that tie Whitesburg to Pineville, it is almost as if one can feel a "presence" rarely discerned. But it is known that you are a discerner to have sojourned this far with us.

Those of *Country Miles Are Longer Than City Miles* are certainly persons whose creations often manifest "soul-like" qualities. Our chronicle is a tribute to all who touch to "feel" and create with utility in mind. What was the ultimate harmony to the inner ear of Ghandi? Little more than a "woo" of the spinning wheel making cloth for a baby's back. Ghandi and Sarah Bailey both have been known to "consecrate" before creating, be it verse or shawl.

But why has history tried to circumvent so many who predicate their lives on giving and souls who move in harmony upon our earth? Why is it that we cannot go to our local bookstore or library and find more volumes on those of euphony and pure artistic vision? It appears that far too many historians concerning themselves with this region have predicated their trust on a hollow humanity and blight-ridden land purposely ignoring evident at-oneness with the earth displayed by those whom we touch in our chronicle and others "just a little beyond."

Where are these places? This valley of the Laurel and Greasy Forks that shelters the Pine Mountain Settlement School not far from Issacs' Creek and the cabin of Gilbert Lewis? Where is Jacob's Branch, that clear energy eternally flowing by the porch of Delta and Belva Hall near Gilley? Those sisters who have sent country butter up to Oaksie Caudill, who dwells a tad above them both. How does one find that great silent river, the Kentucky, as it flows just beyond the vision of the cabin in Viper, that lyric from the Ritchies, and breathes quietly near the cabin of Marshall Thompson, the Rising Moon Potter? Where is the farm of the great Shopville whittler Ed Cress? You must do more than look for his sculpted sycamore.

Because direction is the concern of this chronicle, you may desire to know more than this slight breath of fresh air you have just inhaled, for they are all still great teachers, those who create with love within the lushness of Kentucky's spring, a spring a little more intense than many other springs in many other places. Few places in America can be more fertile than Kentucky in June and yet, when the lushness diminishes, starkness is moving. Most look inward during the latter months of winter.

Oh America! Louisville can be reached by all means known to modern man. Yet this does not detract from late evening strolls through its magnificent parks or upon the banks of that great paradox, the Ohio River. Lexington, the grass once called blue, abundant growth giving rise to one of the most subtly stimulating artistic environments in America, lies to the east and is approachable by all modes of transportation save water. Look tot he small galleries of this fount of thought. If one does not feel subtle when descending to this bluegrass region, continue flowing east following rural routes. Most people understand that life just beyond the Holiday Inn sign is vibrant.

123

Epilogue For those who look to the earth to trace the faint trails of humanity that has trod before and do not desire to loose themselves of all consistency, the most subtle threads of commerce that tie most of our chronicle together are numbered; twenty five east and west, four hundred and twenty one south, one hundred nineteen north, two hundred and twenty one east and one hundred and sixty north. Acquainting oneself with these ribbons that have been gently laid across our great southeastern expanse will reward the perceptive viewer ten-fold. By rereading and exploring those chapters that move, it is possible to read indicators of directions in the text.

Those wishing to visit the vernal north side of the great Pine Mountain and the inhabitants of the valley of the Laurel and the Greasy forks should approach by using the routes listed. In visiting these climes it is imperative one predicate it on first visiting the Pine Mountain Settlement School and asking for guidance. That, of course, is the key to this little journey—asking for guidance. Those approaching from Tennessee should travel to Knoxville, then front the Cumberland Gap as Dr. Thomas Walker did before our independence. Most maps will draw you near; then ask.

Ascending from Ohio and the north, journey to the Bluegrass and chart the rural routes southeast. But pause for refreshment and vision in Berea and partake of the knowledge therein. Few institutions in America have been more instrumental in the perpetuation of the "true and pure" ideals of southern highland culture than Berea College, for it lives today and is more than vestige.

Moving west from northern Virginia, one passes through the northeastern extremity of Kentucky and travels the essence of Jesse Stuart's vision. One should

always stop simply to breath in Mr. Stuart's air. You still have great distances to travel as you follow Route Seven through West Liberty then continue to Wheelwright. This sojourn is a contour at a time and no faster.

The mode, the means, the direction are all insignificant as long as one is prepared for growth through humility when forced to adhere, in part, to the force of a perpetual contour.

Epilogue

ABOUT THE AUTHOR

Craig Evan Royce was born in Oakland, California, and received his B.A. in English education from the University of Kentucky, where he became interested in the people and art of the Appalachian southern highlands. After working for a short time in Lexington's business world, he returned to California and opened a gallery in Laguna Beach that featured the art of the southern highlands. He currently lives in Laguna Beach with his wife.